LICHFIELD
ON PHOTOGRAPHY

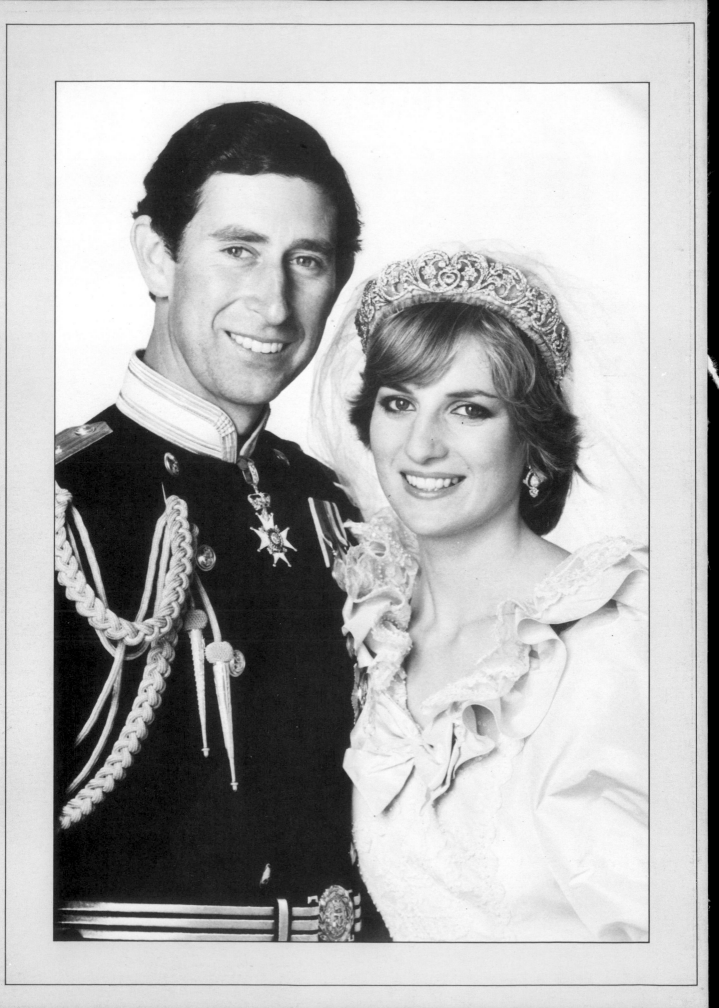

PATRICK LICHFIELD

LICHFIELD
ON PHOTOGRAPHY

Collins
St James's Place, London

1981

William Collins Sons and Co Ltd
London · Glasgow · Sydney · Auckland · Toronto · Johannesburg

Designed and produced for William Collins Sons and Co Ltd
by Bellew & Higton Publishers Ltd, 17–21 Conway Street
London W1P 5HL

Text by Patrick Lichfield and Iain Martin
Art direction by Arthur Ward
Project co-ordination by Nick Scott
Design by Adrianne LeMan
Set in 11 pt Sabon by Western Printing Services Ltd, Bristol
Colour separations by Fotographics Ltd

Lichfield, Patrick
Lichfield on photography
1. Photography
I. Title
770'.28 TR146

ISBN 0 00 216469 8

Made and printed in England by Fakenham Press Ltd

This book is published in conjunction with a series
of three video cassettes also entitled *Lichfield on
Photography* and produced by Original Image Ltd

Opposite title page
The Prince and Princess of Wales
at Buckingham Palace on their wedding day, 29 July 1981.

CONTENTS

INTRODUCTION

Leafing through a book recently I found an apposite quote from Doctor Johnson, that most quotable of men. It seems that some unlucky soul was brave enough to ask the great man for a definition of poetry. 'Why, sir,' he replied, 'It is much easier to say what it is not. We all *know* what light is; but it is not easy to *tell* what it is.'

In preparing this book I have had to face up to the same paradox. As a professional photographer of some twenty years' standing I think I can modestly claim to know what photography is: *telling* what it is turns out to be another matter entirely. As it happens, it has taken many thousands of words and hundreds of pictures—and that is to ignore the effort that went into producing a set of video tapes to tie in with the book. By the time I had finished writing, however, I think I had managed to arrive at a workable definition of photography. By the time you have finished reading the book, I hope you will have too.

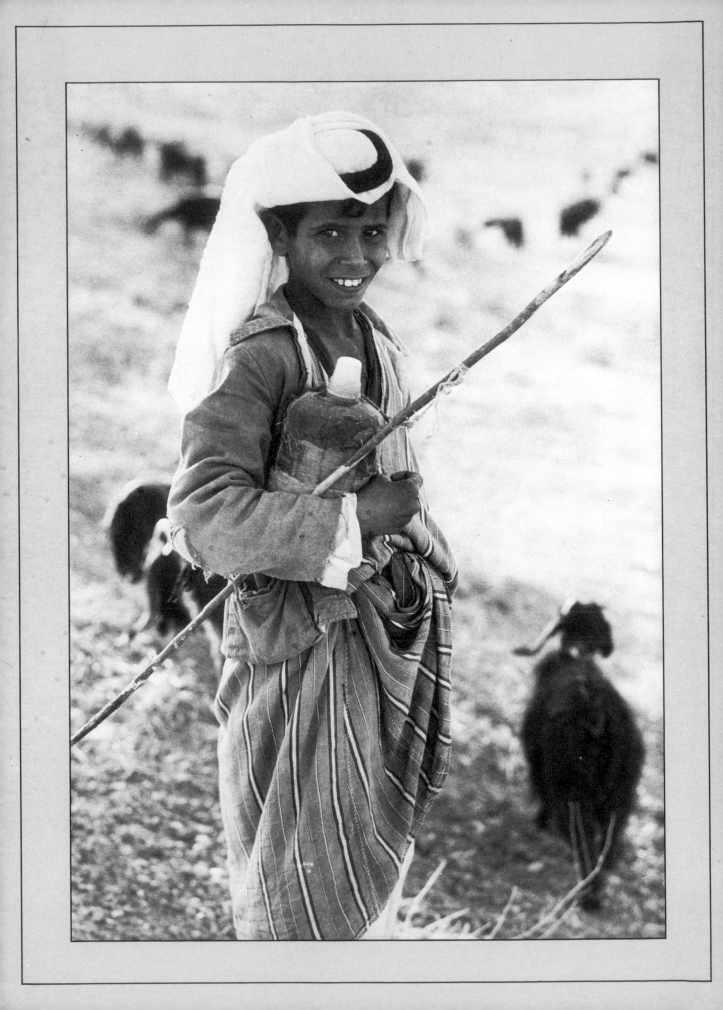

I
FIRST
PRINCIPLES

At first, it seems fairly easy to define photography.
Photography is the process of making photographs.
But what is a photograph? Bill Brandt's famous nudes
are photographs. The recent pictures of the rings of
Saturn are photographs. But what do the two have in
common beside a certain preoccupation with curves?
And what do either of them have to do with the hun-
dreds of pictures I take every year, with subjects that
range from the Bethlehem shepherd boy shown here to
superstars such as Omar Sharif and Ava Gardner?
One thing they have in common is that they are all
taken with a camera. And to answer the question
'What is a camera?' we have, like the White Rabbit, to
begin at the beginning . . .

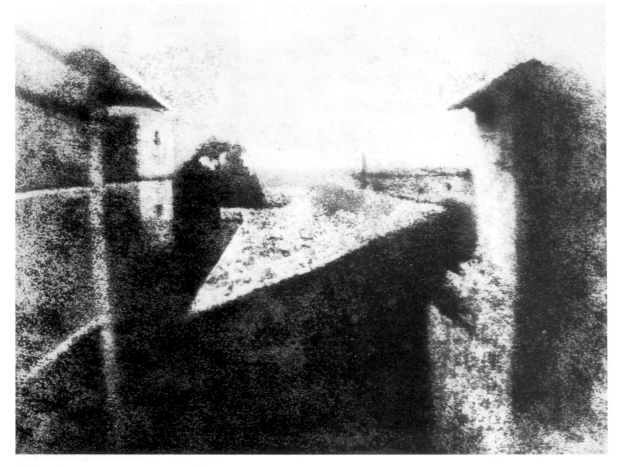

The first photograph, created by Nicéphore Niépce in 1826. While today's exposure times are mere fractions of a second, Niépce's picture required eight hours.

Like, I suspect, most professional photographers, I tend to be too busy taking pictures to concern myself much with the history of the machine I am using. Yet the way in which the camera has developed over the years has inevitably affected the kind of pictures that were taken with it; they, in their turn, have influenced the way we look at photographs today.

The knowledge that light rays can affect certain chemicals has existed since at least 1725, when a German professor of anatomy, Johann Heinrich Schulze, demonstrated the results of exposing salts of silver to the sun.

The word 'camera' goes back even further, derived from *camera obscura*, which means dark room. Almost as soon as men first made themselves shutters that would shield a room from sunlight, they noticed that a small hole in such a shutter invariably cast a bright image of the world outside on to the opposite wall.

Lenses, the other vital part of modern camera systems, are first mentioned in 434 BC in one of Aristophanes' plays. The portable *camera obscura*, which used a lens to concentrate light on to an internal screen, became increasingly popular during the seventeenth and eighteenth centuries.

Working on the same optical principles as the pinhole cameras that I used to play with as a child, these early 'magic boxes' fascinated landscape artists looking for a more accurate way to capture an image of the world.

Gentlemen scientists such as Thomas Wedgwood and Sir Humphrey Davy investigated the possibility of capturing some kind of permanent image by combining the *camera obscura* and plates spread with light-sensitive chemicals, but there was one major problem. As the plates continued to be sensitive to light after exposure they could be viewed only by very dim light if they were to remain unfogged. As Wedgwood and Davy wrote in 1802, 'The profile, immediately after being taken, must be kept in an obscure place.'

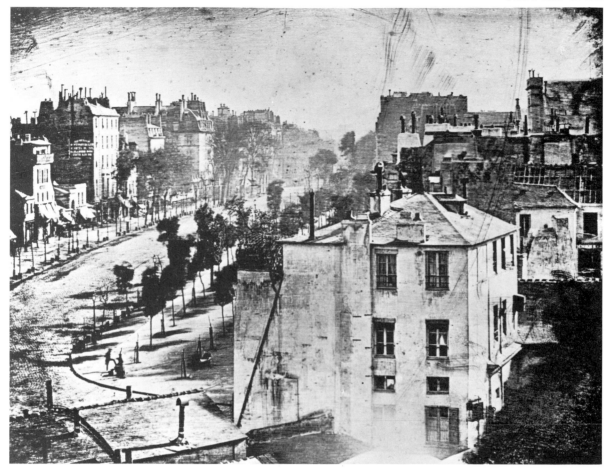

An early daguerreotype of the Boulevard du Temple, Paris, showing perhaps the first person ever to be immortalized by a photograph.

And that is precisely where the infant science of photography remained until 1826, when a Frenchman with the virtually unpronounceable name of Nicéphore Niépce produced the photograph shown here. It is a view of the farm buildings outside his study window at Chalon-sur-Saône, and you can judge the exposure time required by the fact that it records light falling on both the east and the west sides of the courtyard.

For the first time there now existed a photographic image that could be taken out and inspected as often as required without the slightest danger of its disappearing. Niépce's achievement lay in the fact that he succeeded in fixing a *permanent* image, by introducing an intermediate stage into the process that enabled him to wash away all the chemical salts that remained unaffected by light.

And the result pins down one small section of the past so successfully that when we look at reproductions of the photograph today, we still see the same view that he did over a century and a half ago.

Yet despite the importance of Niépce's breakthrough, photography remained an obscure scientific freak until some years after his death, when his partner, Louis Daguerre, revealed details of a new, improved process which he modestly called daguerreotypy.

Daguerre's basic photographic plate consisted of a silvered copper sheet which was sensitized to light by exposure to iodine vapour, producing a coating of silver iodide. After exposure the plate was developed with mercury vapour, fixed with hyposulphite of soda, and finally washed with distilled water.

The result of this quasi-alchemistic approach was a pattern of grey shapes on a silvered background which, when held at precisely the right angle to the light, revealed a clear and detailed image of frozen reality.

However, although exposure times for the new process were much shorter than Niépce's

original eight hours, the twenty or thirty minutes needed meant that the range of potential subjects for photography was, to say the least, rather limited.

None the less Daguerre's discovery caught the imagination of many of the more enlightened members of the scientific community, and was considered important enough to be bought by the French Government on behalf of the people in 1839. The news was broken to the general public in an exclusive article in a French newspaper, an article that pointed out the aspect of the whole affair that most worried the craftsmen of the time, that photography would 'revolutionize the art of drawing'.

But revolution was not a high priority with early photographers. They were too busy taking photographs to worry about the implications for artists. Anything would do for a subject, provided it stood still long enough to be captured on a photographic plate, and the result was an almost exhaustive documentation of the streets of Paris, made strangely empty by the absence of people, all of whom moved on too quickly to be captured. (There is one exception to this rule, probably the first person ever to be photographed: a man standing on the Boulevard du Temple. He could not move because he was in the process of having his shoes blacked at the time.)

Further technical improvements brought exposure times down to more realistic levels, and photography began to establish itself.

Familiar as we are today with the countless uses of photography, it is all too easy to forget what an extremely potent idea it was. Here for the first time was a way to obtain a direct copy of life, without needing to involve the expensive skills of a professional artist, a copy so realistic that it was as if Nature herself had drawn it.

It was a concept that had appealed to many people for a long time, as witness a remarkable book by another Frenchman, Charles François Tiphaigne de la Roche. In *Giphantie*, published in 1760, he writes of a magic country and in particular a magical hall, the windows of which are filled with images of a storm at sea. Somewhat surprised to come across this view when he thinks himself in the middle of the desert, the hero rushes to look out of the windows and is disconcerted to find himself stunned as his head hits what is in effect an enormous photograph: 'I could not take off my eyes from the picture. A sensible spectator, who from the shore beholds a tempestuous sea, feels not more lively impressions; such images are the equivalent of the things themselves.'

By 1840 these fantasies had become a scientifically proven possibility. No wonder that many people thought of photography as the devil's work and refused to have anything to do with it. (This attitude still persists today, as I have discovered, to my cost, in countries such as Kenya.)

But for most people the magic of photography far outweighed any dubious moral questions; particularly so for the new generation of prosperous middle classes for whom the latest advances offered a new way of immortalizing themselves.

The first public portraiture studio in Britain opened on the roof of the Royal Polytechnic Institution on 23 March 1841 and was an immediate success. Seated on a raised platform so as to be closer to the light, with their heads held firmly in position by metal clamps, the rich and the beautiful remained perfectly still for minutes on end as their images were recorded for posterity.

Ordinary people had to wait until cameras became compact enough to be taken out on to the streets before they could feature in the work of early photographers such as Hill and Adamson; for the time being photography was the province of the rich, with a small 1½ × 2-inch portrait costing as much as a guinea a time.

Today we tend to think of a good portrait as one that somehow captures the essential personality of a sitter, often despite his or her best efforts to maintain a certain distance. In 1840 there was no way for a photographer to catch such candid shots; people had to choose the pose they fancied and hold it whilst the emulsion went to work.

The fact that a photographer composed his picture by focusing on a ground glass screen where the sitter's image appeared upside down and back to front did not exactly encourage rapport between photographer and subject.

Indeed, portrait sessions in the early days could be extremely disorienting experiences, especially as the windows of most studios were

Fox Talbot's calotype process revolutionized photography by introducing an intermediate negative, which allowed an infinite number of pictures to be reproduced from a single original.

tinted dark blue for technical reasons, making the whole place more like an aquarium than anything else.

Above all there was the fact that for most people photographic portraits would probably be a once-in-a-lifetime experience, the only opportunity they would have to decide how people would remember them when they were no longer around.

There were however certain rather more informal daguerreotypes on offer—the so-called *académies*, a somewhat pretentious pseudonym for pictures of naked women; these were considered indecent by almost everyone other than the 'artists' for whom they were intended.

The particularly intimate appeal of these early attempts at pin-up photography must have been reinforced by the once-only nature of daguerreotypy. The process produced its results directly on the original plate and there could be no copies, no need to share the girl in your pocket with millions of others.

Characteristically it took an Englishman to change all that.

William Fox Talbot had been pursuing experiments along similar lines to those of Niépce since 1834. In 1841, he patented a process that had at least two major advantages over Daguerre's, one technical and one practical.

Talbot's first improvement was to develop the 'latent image' concept. He realized that it was not necessary to wait for the image to develop inside the camera, and that exposure times could be cut dramatically if the image was later 'amplified' by treatment with various chemicals.

However, his single largest contribution to the history of photography was his introduction of an intermediate *negative* stage. Unlike

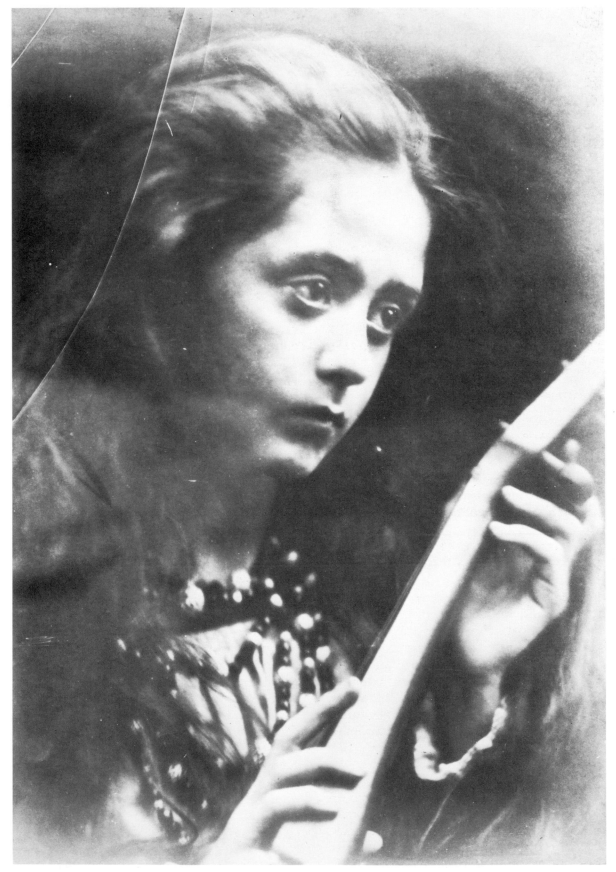

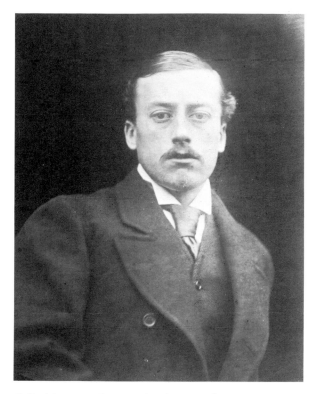

Julia Margaret Cameron's pictures of my great-grandfather and my great-aunt appear positively informal when compared to other studio portraits of the late nineteenth century.

lens, which cut down even further the length of time required for a successful exposure.

But although calotypes had their advantages, they still could not match the daguerreotype in the recording of fine detail, mainly because of the loss of quality inherent in the use of paper negatives.

Frederick Scott Archer's wet collodion process (1851) combined the best of both worlds, using fine-grained glass negatives that required exposure times of only a few seconds in a good light. But these suffered from one big disadvantage: they had to be exposed and developed whilst still wet, which made the photographer's equipment extremely cumbersome.

For the studio portraitist this was relatively unimportant, but there was by now a growing number of photographers who wanted to take their cameras out into the world in search of pictures (the early beginnings of documentary photography).

One of the founding fathers of this school was Mathew Brady who, despite the problems involved, managed to produce a whole series of photographs documenting the American Civil War using the wet collodion process.

Brady was one of the few people to realize the camera's ability to immortalize history as it happened, and the impact of his Civil War pictures is only slightly diminished by the knowledge that 'Mathew Brady' was in fact at least twenty teams of photographers—Brady, who was in fact half-blind, had men in all parts of the Army, 'like a rich newspaper'.

Although photography was still a long way from being the hobby of millions that it is today, interest was by now beginning to spread out beyond the professional and scientific community to embrace the more open-minded members of the middle classes.

Nobody is more typical of this growing band of amateurs than Julia Margaret Cameron, who first took up photography when her daughter presented her with a camera in 1864. Using a converted chicken coop as a studio, Mrs Cameron became fascin-

the daguerreotype, in which the action of the light produced a positive pale grey image, Talbot's photographic paper turned black when exposed to light. A positive image could then be obtained by exposing a second piece of photographic paper to light filtered through the original negative.

And when you have a negative, you have the possibility of reproducing an infinite number of identical images from one single exposure. Photography had entered the age of mass production.

Whereas before men knew of foreign places and people only from traveller's tales, it was soon to become possible for them to hold the Matterhorn, the Gobi Desert and Niagara Falls in the palms of their hands, captured in three small photographic reproductions.

Talbot called these reproductions 'calotypes', from the Greek for beautiful pictures, and the advances that he introduced in the chemistry of photography were matched by similar improvements in camera design. These included developments such as the Petzval

Overleaf An early picture of my family on the steps at Shugborough. I still cannot make up my mind if this is a formal group portrait gone wrong or simply a casual snapshot.

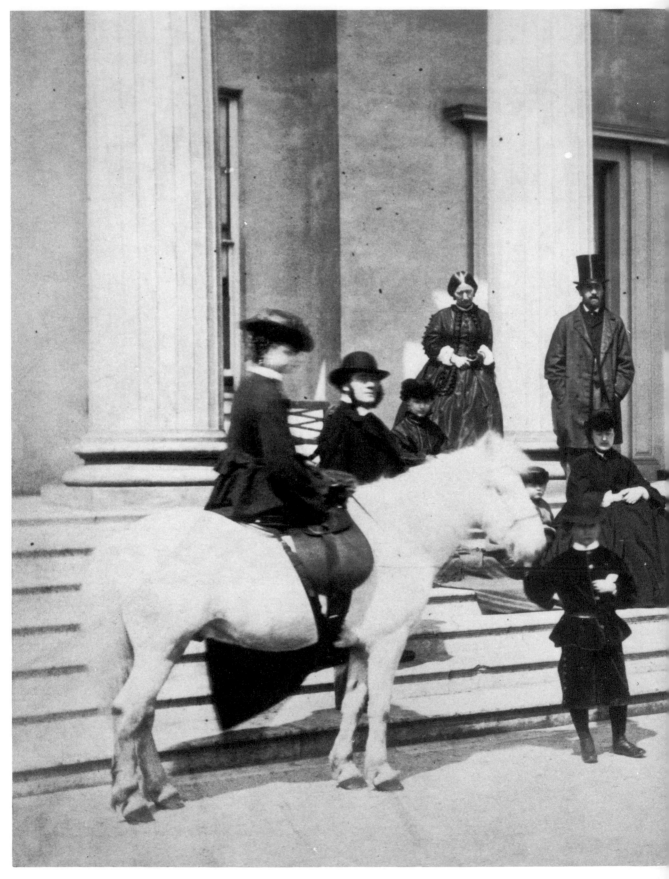

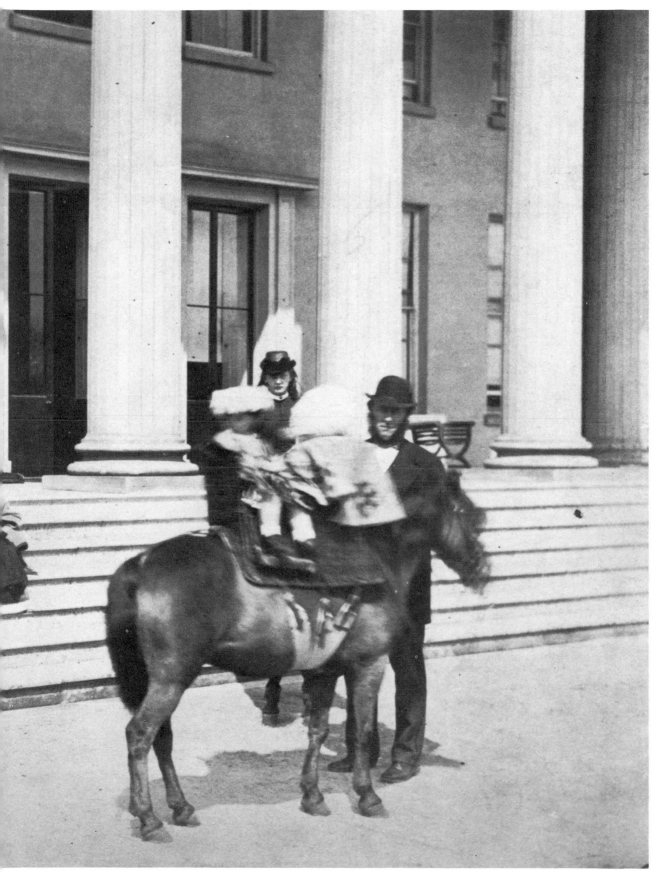

ated, taking endless portraits of her next-door neighbour, the poet Tennyson, luminaries such as Carlyle, Darwin and Longfellow, and the man who first coined the word 'photography', Sir John Herschel.

She wrote, 'When I have such men before my camera my whole soul has endeavoured to do its duty towards them in recording faithfully the greatness of the inner as well as the features of the outer man,' and her portraits are noticeable for their rather more relaxed attitude towards the sitter, demonstrating a lack of self-consciousness that had been noticeably absent in previous photographic portraits.

Paradoxically, although we now tend to admire Julia Margaret Cameron's pictures for their artless informality, she was, like most other well-bred Victorian ladies, much preoccupied with Art.

Unfortunately her efforts in this direction were less sure-footed. In retrospect her 'fancy pictures', in which faintly bewildered kitchenmaids find themselves pressed into service as sea-nymphs, seem rather embarrassing, all too reminiscent of the worst aspects of Victorian sentimentality.

This over-serious attitude towards 'artistic' photography is one of the more noticeable characteristics of the pictorial photography of the time, and is demonstrated by the story of Julia Margaret Cameron's involvement with *Idylls of the King*. Tennyson, who much admired her work, suggested that she should produce a series of photographs to accompany his text and she set about the task with her customary enthusiasm, dragooning everyone around her into posing as assorted Lancelots, Guineveres and King Arthurs.

The results were much admired, but as it was not until the 1890s that it became possible to reproduce photographs the illustrated edition of the *Idylls* contained not photographs but woodcuts, laboriously copied from her originals.

Serious artists of the day had ambivalent attitudes towards photography.

For them the medium was, at best, simply a convenient source of reference material whilst, at worst, it threatened their very existence as licensed reproducers of reality. Relations between the two media cannot have been made any easier when painters saw early portrait photographers make a virtue out of necessity by advertising 'The Rembrandt Effect': the strong contrast between light and shade produced by the primitive lighting conditions common in most portrait studios.

Photography still had quite some way to go before it could begin to concentrate on aesthetics rather than technology.

The single most important advance was represented by the dry gelatin plates announced by Dr Richard Leach Maddox in 1871, and within seven years improvements in the basic process made it possible for factories to mass-produce photographic plates that required exposures measured in mere fractions of a second.

The snapshot was born.

I came across the group portrait shown on the previous page only recently, whilst leafing through the collection belonging to Lord Lansdowne, and if my calculations are correct it shows, amongst others, the same man that appears in the picture on page 15—my greatgrandfather, the 3rd Earl of Lichfield.

Notice the enormous difference between the two photographs.

For Julia Margaret Cameron, the complexities of coping with collodion plates that had to be exposed and developed before they had had time to dry meant that random elements had to be kept to an absolute minimum if the precious photograph was not to be ruined.

The group portrait, on the other hand, freed from the constraints of collodion, exhibits a sophisticated lack of concern for the final product that seems almost aggressively careless by comparison.

In my own mind, I am still none too sure about certain aspects of the picture. Have the children on ponies, shown in the foreground, wandered into the frame by accident, unnoticed by the anonymous photographer until it was too late?

Or were they actually intended as the main point of interest in an informal group portrait, taken by somebody without any preconceptions about photographic composition?

Whichever is the case, somebody thought enough of the picture to take the trouble to print it, and the result is typical of the millions

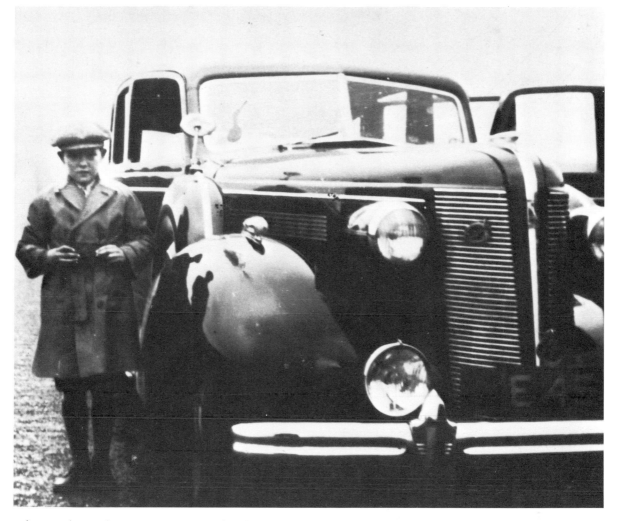

My first camera: a picture of me and the family Buick, taken by my grandfather when I was eight.

of snapshots that were soon to hold pride of place in Victorian albums, becoming more and more common as people embraced the new craze for photographic likenesses.

By the time I got my first camera, at the age of eight, the special magic that had been such a strong facet of early photography had virtually evaporated, and the camera had become almost as unremarkable as the motor car. For my mother, the camera she gave me was little more than a sophisticated toy that might serve to keep a small boy out of trouble for a few weeks.

To me, it was not so much a magic box as a highly coveted status symbol, even more desirable than a ride in the family's massive 1938 Buick.

Neither she nor I realized that that anonymous Russian camera was to be the first of many cameras I would use during my photographic career.

In the fifty or sixty years that separate this early picture of me from that earlier portrait of my ancestors at Shugborough, the impetus of photographic technology had switched direction, from being concerned mainly with film processes to camera design. My next camera, which I remember was called a Retinette, represented a considerable advance on the rudimentary popular cameras of the past.

A major factor in all this was George Eastman's introduction of the first real mass-market camera—the Kodak. Significantly, the brand name had been chosen because it could be pronounced easily in any language, and it was designed to make life as simple as possible for people who were more interested in pictures than they were in complicated hardware. It had a one-speed shutter, fixed at $\frac{1}{25}$th-of-a-

second, and a fixed-focus lens that produced a sharp image of everything in a picture further than 3½ feet away from the lens.

But the Kodak's most popular feature was also its simplest. The owner did not even have to bother to remove the used film from the camera; the entire box was simply wrapped up and posted off to the factory, where the prints were processed and the camera reloaded, ready for another hundred shots.

The subsequent launch of the so-called Box Brownie expanded the market even further, to the extent that one commentator could say, 'Now every nipper has a Brownie, and a photograph is as common as a box of matches.' Even my grandfather, not the most frivolous of men, owned one.

Although Eastman also introduced a new kind of roll-film, with a flexible cellulose base, for his cameras in 1889, roll-film did not become standard for quite some time, and glass plates remained in use right up until the Second World War. Even the highly regarded Ermanox, the first truly portable camera to be equipped with the fast f2 lens, used fast panchromatic glass plates rather than roll-film.

The major breakthrough between the wars was undoubtedly the Leica—a precision-built professional camera that incorporated a focal-plane shutter and a very high-quality f3.5 lens. Even more radically, the Leica used 35mm film, much smaller than other film formats of the time, and originally designed to be used in movie cameras.

Despite the fact that the Leica included such revolutionary refinements, its early popularity was hampered by the graininess of the new film, which was unable to match the sharpness provided by the Elmar lens.

However, as the quality of 35mm film improved, photographers began to appreciate a feature which was to become a standard fitting on later Leicas: the coupled rangefinder. With cameras that were equipped with variable-

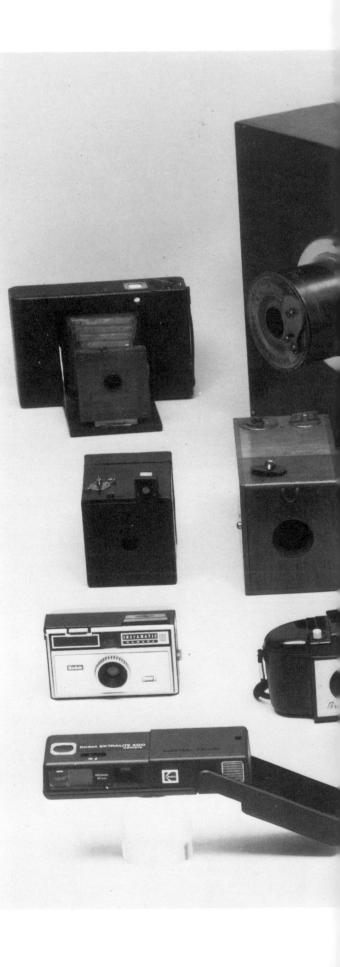

A selection of cameras from the collection of the Kodak Museum of Photography ranging from a replica of the cumbersome sliding-body camera of the 1840s (**top centre**) to a modern 35mm SLR complete with zoom lens (**front centre**). Other cameras shown include the Kodak of 1891 (**second from left, back row**), an early Leica (**right, middle row**) and a Kodak Instamatic (**bottom left**).

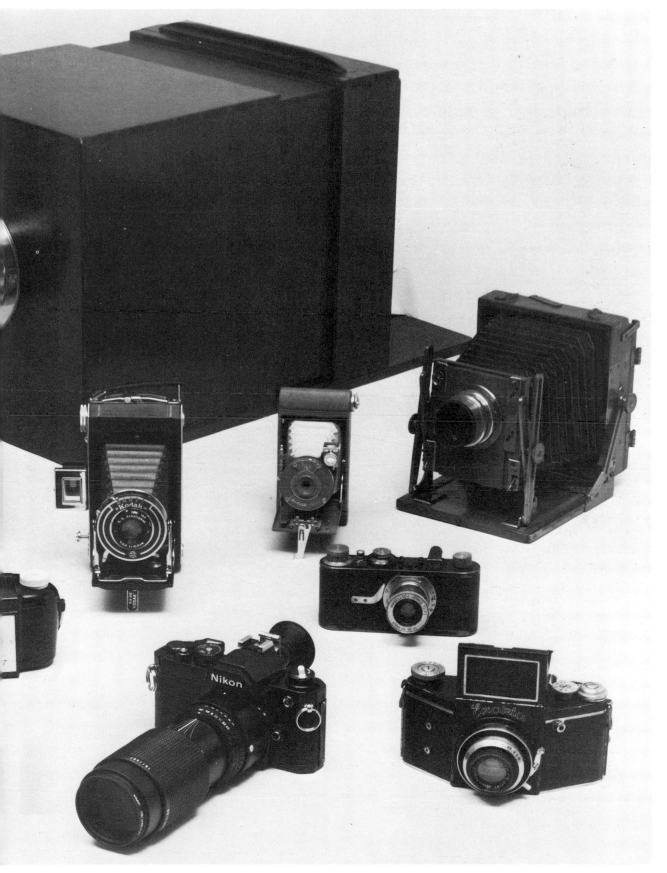

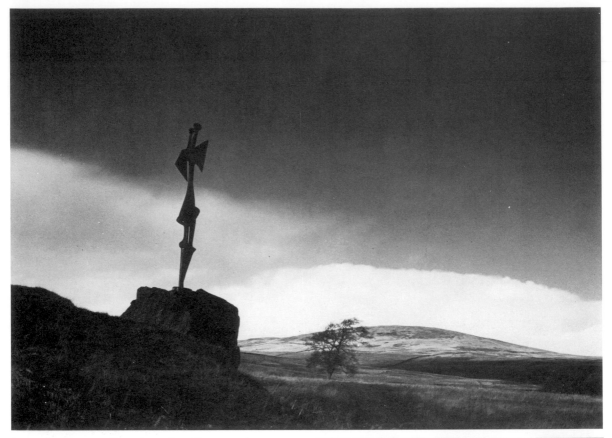

focus lenses, estimating the distance between camera and subject had hitherto been more or less a matter of educated guesswork, something that may account for much of the soft-focus effects that are characteristic of early pictures. But as lenses became more efficient and films more sensitive, setting the right distance on the focusing scale became more and more important.

The Leica's rangefinder ensured that the camera could be correctly set for sharply focused photographs no matter how far the distance between camera and subject, and it was the first of many sophisticated devices designed to improve the correlation between the picture the camera took and the picture the photographer saw through his viewfinder.

The Rolleiflex, the first of the truly popular twin-lens reflex cameras to make an impact, replaced the crude glass window of early viewfinders with a view through a second, twinned lens, mounted immediately above the main lens and giving a far more accurate impression of the subject as seen by the camera.

And although the idea of a *single*-lens

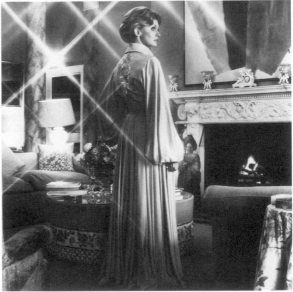

Of the various film formats now available 2¼ (inches) square (**above**) is used mainly by professionals for studio portrait work whilst 35mm (**top**) has established itself as the standard for most other types of serious photography.

Here, the top picture shows a sculpture by Henry Moore in a Scottish landscape, while the lower picture is a studio portrait of Olivia Newton-John. A star filter was used in this shot to create the effect of sparkling rays of light.

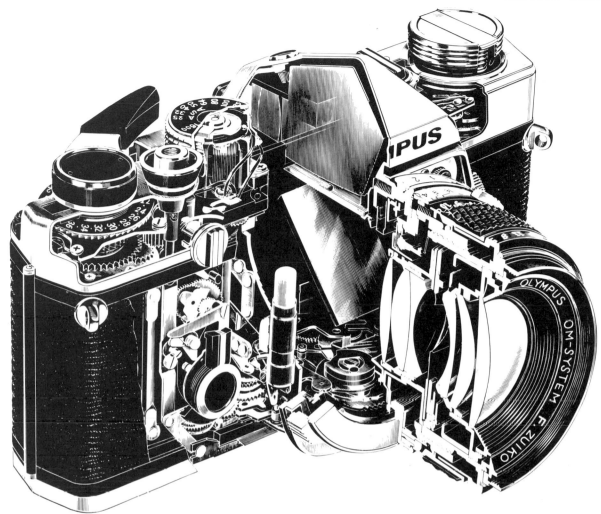

Above The modern 35mm single-lens reflex camera, a sophisticated piece of equipment which utilizes complex electronic circuitry to remove much of the guesswork from the process of taking pictures; at the same time it eliminates parallax error by showing exactly what the lens sees reflected in the viewfinder.

reflex camera had been mooted as early as 1861, it was only during the late 1950s that SLRs really began to establish themselves, led by the now justly famous Hassleblad.

In its latest, extremely compact, incarnation the 35mm SLR camera is now often the standard against which all others are judged, even in hypercritical professional studios.

Today's fully automatic cameras, equipped with a sometimes bewildering variety of electronic hardware, enable anyone who can master their controls to freeze reality into a series of perfect pictures. Pentaprism viewfinders with interchangeable screens present a highly accurate view of the picture as it is taken, along with a twinkling array of light-emitting diodes that signal everything from settings on the camera to a lack of suitable light.

Split-image rangefinders ensure pin-sharp focusing and micro-electronics co-ordinate

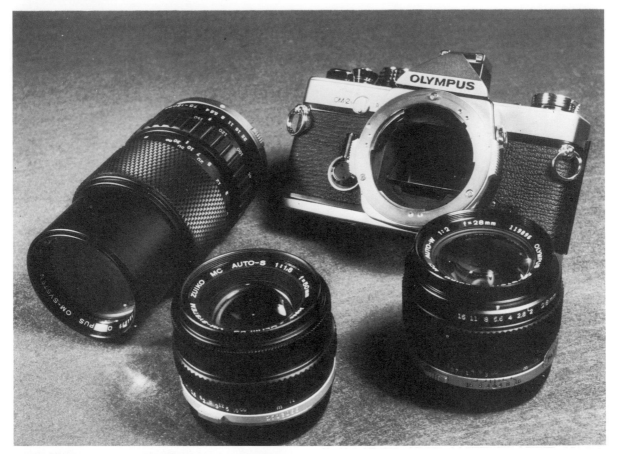

Above A photographer's basic equipment and (**left**) what he needs for cleaning it.

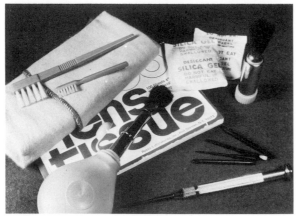

film speed, shutter speed and f stop for maximum flexibility.

Sophisticated through-the-lens exposure metering systems measure the light as it is reflected from the subject and adjust the aperture and exposure controls within fractions of a second.

Parallel with these developments in camera design has been the rise of the 'system'. A truly dedicated hardware fiend can now spend thousands of pounds equipping his basic camera with a host of alternative fixtures and

Opposite The equipment he uses depends on the type of photographs he wants to take. Portrait photography can be done on (**top**) a medium-format camera or a 35mm SLR (shown here with 85mm lens), with twin flash heads or photoflood lamps, an independent light meter and a tripod with optional cable release. Sports photographers will prefer (**below**) a 35mm SLR with motordrive or power winder, a high-speed flash gun with camera bracket, a long lens like this 500mm mirror lens, a zoom such as an 80 to 200mm, or a standard 50mm lens. A rifle grip with built-in release will help steady longer lenses whilst a twin-lens reflex camera makes panning with moving subjects easier to control. Landscapes can be taken on (**centre**) either 35mm SLRs or larger-format twin-lens reflex cameras, steadied by a tripod and cable release and using a variety of lenses (shown here, 24mm, 135mm and 35mm). A camera clamp can steady the camera when a tripod is not available and various filters can be used to create different effects. Nature can be photographed with (**top right**) an SLR equipped with bellows and macro lens for ultra close-up work, again with the camera held steady on a tripod and triggered with a cable release. Motordrives or autowinders save seconds and a 75–150mm zoom or 300mm telephoto lens (**bottom**) brings distant subjects closer. Brackets can replace a tripod and a long air-release can trigger the camera without alarming timid subjects.

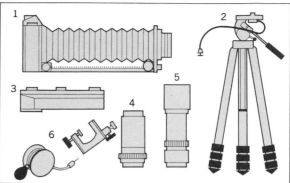

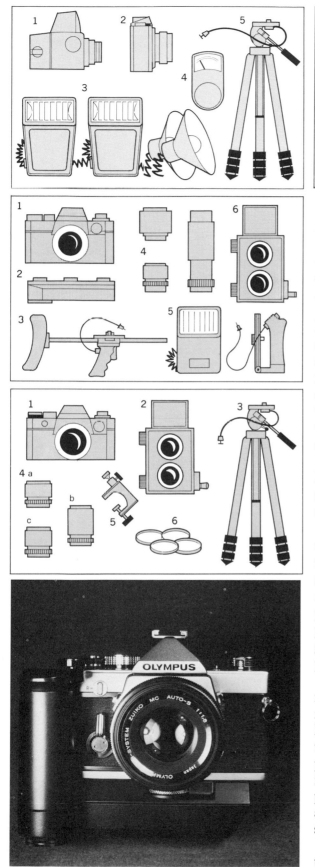

fittings, ranging from motor drives that enable him to squeeze off five pictures within the space of a single second to a wide range of coloured and special-effects filters that will obligingly divorce the finished photograph from any semblance of reality.

As distinct from the one-speed, one-stop lens of the first Kodak, cameras are now designed to take a bewilderingly varied selection of lenses with focal lengths of anything from 9mm up to 2000mm, and from a fixed position a well-equipped photographer can now capture everything from his immediate field of vision to the previously impenetrable distances of a mountain peak.

Even the availability of suitable lighting no longer governs the choice of subject when sophisticated flash guns can provide cheap instant light at the push of a button.

This 'de-skilling' of photography has inevitably had an effect on photographs, changing them from magic totems into a common currency. When anybody can pick up a camera, familiarize himself with the controls and proceed to take thirty-six perfectly exposed pictures, there is very little magic left in photography, only certain nagging doubts as to what photography is actually *for*.

Because, despite the fact that the medium is now over one hundred and fifty years old, its role remains curiously undefined. Certainly we know that its ability as a recording medium is unparalleled, as witness the astonishing pictures of objects as small as a human hair follicle and as large as Saturn. But with inexpensive video equipment offering the ability to add movement, and holograms the ability to show depth, how long can that last?

Home video also challenges photography's traditional role as keeper of the family archives,

a purpose which it has jealously guarded since its earliest days. The claim made of the first Kodak that 'A collection of these pictures may be made to furnish a pictorial history of life as it is lived by the owner, that will grow more valuable every day that passes' applies equally well to a video camera.

There remains the question of Art.

Ever since photography was first invented, photographers have preoccupied themselves with its relationship to the established art forms, constantly returning to the basic question, 'Is photography an art?' (to which the answer can only be 'What is art?'). The history of that shifting relationship is complex, and the question itself is discussed in detail in chapter eight, but meanwhile it is interesting to note that many avant-garde photographers are currently returning to the basic snapshot for inspiration, contrasting the arbitrary nature of the medium with the concept of 'the decisive moment' so highly regarded by past masters of photography such as Cartier-Bresson.

One of the main prerequisites of an artist's life, as I understand it, is that it should oppose existing ways of thought in an attempt to re-dress the balance and force us to re-examine our preconceptions. And the glorification of the simple snapshot certainly provides us with a refreshing counter-balance to our current fetish for technology.

After all, as any self-respecting Luddite will tell you, too much technology can be a very bad thing. Inexpensive access to sophisticated camera technology is creating a whole new generation of dedicated cameramen, but very few photographers.

It is always easiest to be wise after the event, but there is a story about E. J. Bellocq that illustrates the point rather well. Although Bellocq was a professional photographer who made his living by taking commissioned pictures of ships and machinery, he is best known to us for the series of photographic portraits he made of the whores of Storyville, the red-light district where New Orleans jazz was born. Far from being erotic, Bellocq's Storyville portraits have a curious air of detachment, mysteriously enhanced by the fact that in several of the pictures the faces have been scratched out of the emulsion (a strange thing to do when it

would have been much easier to preserve anonymity by smashing the glass plates with which the photographs were taken). As it is, the portraits were discovered only after his death, locked up in his desk. Bellocq is also said to have taken pictures inside the notorious Chinese opium dens, but unlike the other pictures these have not survived. Anyone who has seen the film *Pretty Baby* may care to note that Bellocq, according to his friends, was in fact a rather Toulouse-Lautrec-like figure

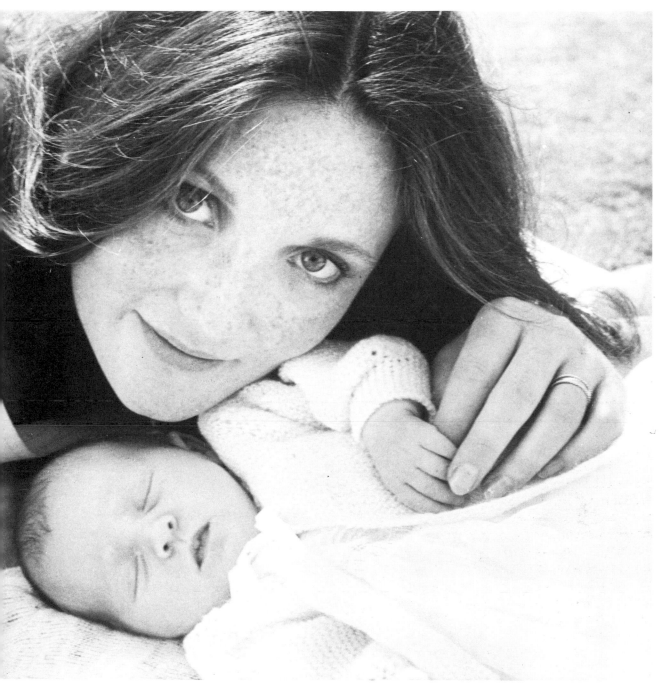

My wife Leonora and my daughter Rose. 35mm single-lens reflex cameras have brought unprecedented flexibility and accuracy to photography, as well as producing improved results with traditional subjects.

of a diminutive stature and with 'a voice like an angry squirrel'.

In later life Bellocq was particularly anxious to get a picture of a streetcar which had been painted red, white and blue and was used as an advertisement for War Bonds. But by now his glass-plate camera had been replaced by the last word in photographic technology of the time, Kodak's 1938 Bantam Special. This camera included a rangefinder amongst its refinements.

Try as he might, Bellocq never managed to get a picture of the whole streetcar, only portions of the front or back of it as it moved off down Canal Street.

He was always too busy trying to adjust the rangefinder.

2
AN OPEN AND SHUT CASE

From a mechanical standpoint, taking a picture like the one of Lesley Caron shown here is very simple. You open a camera up to the light for the required amount of time and then you shut it. If everything is working as it is supposed to, you should have a perfect record of one particular split second of time immortalized on film. But of course it is never really as simple as that. Leaving aside the problems of how you get Lesley Caron to pose for you, where you choose to photograph her, which film, which camera, which lens, and most important of all which particular split second you choose to immortalize, there remains the basic difficulty of adjusting the amount of light you capture to suit the film you are using. Perhaps a little knowledge of the physical process involved would increase your chances of success . . .

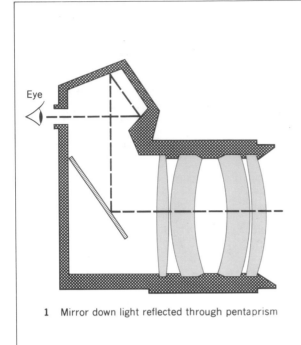

1 Mirror down light reflected through pentaprism

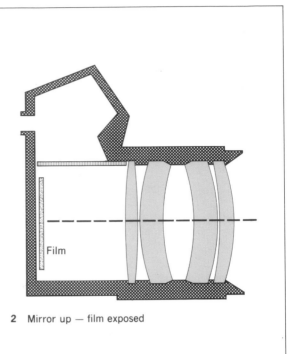

2 Mirror up — film exposed

Photographic equipment has evolved so far and so fast in the last one hundred years that Julia Margaret Cameron and her contemporaries would find themselves totally mystified by a modern 35mm SLR. Photographic styles have also changed, from the stiff formality of early studio portraits to the casual informality of the modern snapshot. None the less, the basic principles are exactly the same.

Patterns of light rays, reflected off a chosen subject, are channelled into the camera by the lens, modified by the shutter and the diaphragm, then stored on a thin film of photographic emulsion.

While lenses and films deserve, and have, chapters of their own, I would like to concentrate here on the basic physics of photography, and the way in which the light itself is controlled by the choice of shutter speed and aperture.

The shutter, which in most cases works rather like a pair of stiff curtains, selects the length of time for which the film is exposed to the light. The diaphragm, on the other hand, controls the amount of light by moving a set of interleaved metal blades either in or out of the light path.

Working in tandem, these two devices control the flow of light on to the film to produce the optimum exposure, that is, the amount of light required to produce an image that best

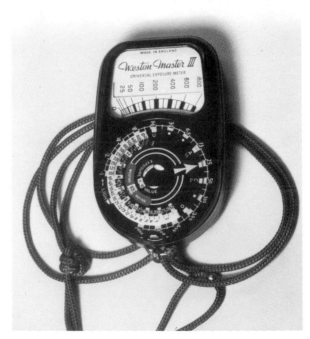

Top Prior to exposure the mirror in an SLR reflects light up into the top of the camera and through a pentaprism to present an accurate picture of what the lens sees. As the shutter release is depressed the mirror flips up out of the path of the light allowing the scene or subject to be recorded on the film. **Above** A light meter, mounted either within the camera body or used as an independent accessory, measures the amount of light in a scene and translates it into the required exposure values, which makes it considerably easier to achieve properly exposed pictures in otherwise tricky situations (**right**).

represents the tonal values of the subject. A dark subject, such as the oft-quoted cat in the coal cellar, reflects very little light and therefore requires a long exposure if its image is to be correctly captured. A light subject, say a polar bear on an iceberg, reflects a lot of light and therefore needs a very short exposure.

Prior to the introduction of mass-produced photographic plates in the 1870s, the sensitivity of emulsions was so variable that a cor-

rect measurement of a subject's light values was, by and large, irrelevant. In any case, most lenses had only one aperture setting, and exposure was controlled by the simple expedient of removing the lens cap and counting off the number of seconds that seemed appropriate.

But as emulsions became more reliable, judging the right exposure became more and more important. Consequently, a variety of light-metering devices became available. The

Above Britt Ekland by a river. Backlit shots like these are amongst my favourites but require careful consideration of exposure values. **Right** Studio head shots like this need accurate control of depth of field for overall sharpness.

most rudimentary of these required the photographer to set a series of interconnected levers, indicating the time of day, the season of the year, the position of the sun in relation to the subject and so on. The proper exposure values could then be read off and set on the camera.

More sophisticated systems were based on a series of filters of increasing density, which had to be held up in front of the subject. The photographer found out how to set his camera controls by noting which particular filter made his subject no longer visible, which explains their rather macabre name: extinction meters.

Comparison photometers, in another development, compensated for the human eye's ability to adjust itself to changing light levels by introducing a secondary light source, such as a candle, to act as a fixed reference point against which to monitor the available light.

Inevitably, the complex nature of these various devices tended to restrict most photographers in their choice of photographs, producing a bias towards pictures that could be taken in full daylight, and preferably at noon. Doubtful lighting situations were avoided whenever possible.

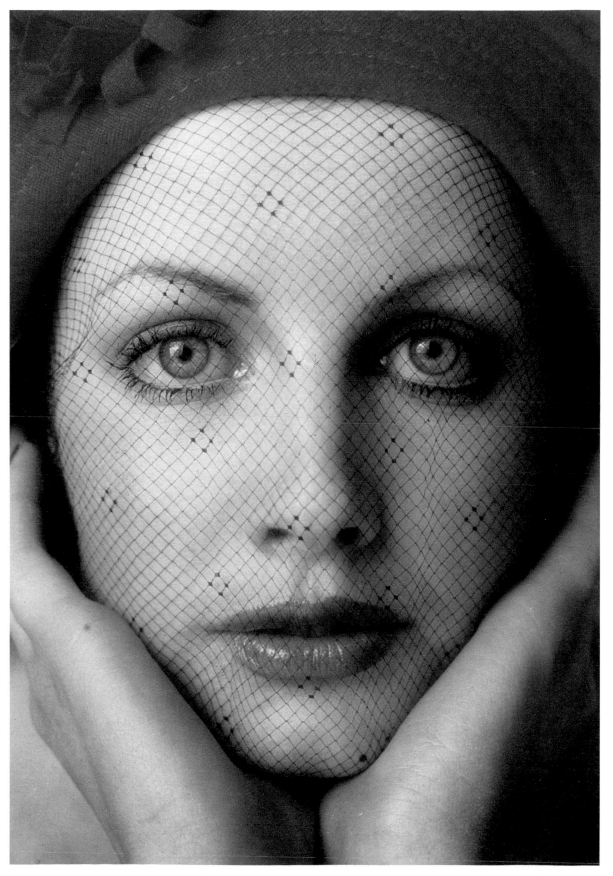

A distinct improvement in flexibility came with the introduction of the new generation of highly accurate, versatile light meters based on photo-electric cells, which produce a varying level of electric current that depends on the amount of light falling on their sensors. The current moves a needle across a calibrated scale, and the light values can be read off.

By far the most successful of these photo-electric meters was the Weston, first introduced in 1932 and later modified to allow the photographer to monitor either the overall brightness of a scene or selected highlights within it.

Until quite recently a light meter such as the Weston was essential for anybody who had aspirations to be anything other than a snap-shot photographer, and I can remember the feeling of budding professionalism I experienced when I first learnt how to use one. Today the advent of cadmium sulphide cells has produced light-metering systems that are small enough to fit right inside the camera, where they can directly monitor the settings of the diaphragm and the shutter and, in fully automatic cameras, actually control them.

It strikes me as rather ironic that the 'point-and-shoot' nature of today's automatic cameras has taken us almost full circle, back to the time when George Eastman advertised his Kodak camera with the slogan, 'You press the button, we do the rest.' There is one major difference, however. In the old days, despite Eastman's proud boast, the range of decently exposed pictures possible was limited to those which suited the single shutter speed and fixed aperture of the Kodak. Today, it is almost infinitely variable.

Rather than regarding the mysteries of dia-phragm and shutter as technicalities best left to the professional, today's camera enthusiasts are free to start taking advantage of the radi-cally different effects that are possible by selecting different settings on the camera.

No longer hampered by the task of having to calculate the correct exposure values, he can begin to experiment, selecting the aperture or speed he wants to produce the kind of picture he has in mind. He can utilize the aperture scale to alter the depth of focus—throwing one object into sharp relief against an unfocused background, or achieving pin-sharp results

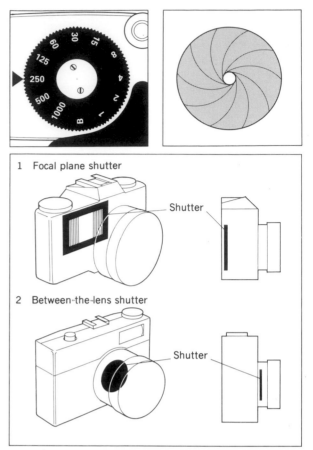

1 Focal plane shutter

Shutter

2 Between-the-lens shutter

Shutter

across the whole picture. He can alter the speed of the shutter to freeze a moving subject in mid-flight, or blur it into a metaphor of movement . . . always provided, of course, that he knows what he is doing.

Brainwashed as we are by the pervasive influence of technology, it is all too easy to underestimate the primitive magic that lies at the heart of photography—that brief moment when a flash of light is allowed to imprint itself permanently on film. The French photo-grapher Cartier-Bresson called one of his most important books *The Decisive Moment*, a phrase that not only sums up his whole approach but also serves as a salutary re-minder that whatever is happening in front of the camera at the moment the shutter opens irrevocably determines the nature of the fin-ished photograph.

On that basis alone the shutter can jus-tifiably claim to be the single most important element in a camera. And like any other important idea, the concept is essentially very simple. All that is required is some kind of device that can be snapped out of the way of

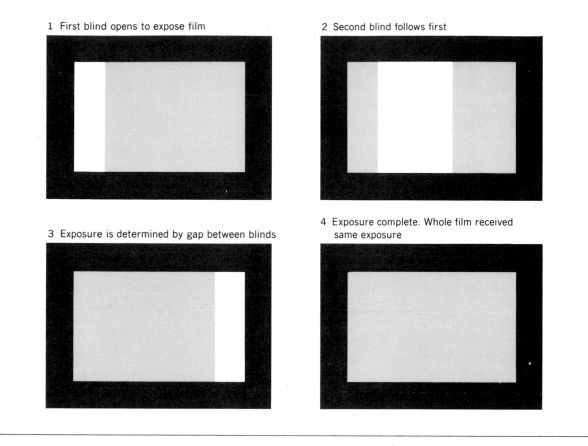

1 First blind opens to expose film

2 Second blind follows first

3 Exposure is determined by gap between blinds

4 Exposure complete. Whole film received same exposure

Top left Shutter speeds, expressed in fractions of a second, are selected with the shutter speed dial, often mounted on the top of the camera. The size of the aperture is controlled by a series of interlocking blades. **Above left** Focal plane shutters are mounted immediately in front of the film. Between-the-lens shutters work on the same principle as the diaphragm, folding open to admit light, snapping shut to exclude it. **Above** Focal plane shutters consist of a pair of light-tight blinds. When the shutter release is depressed the first blind slides open admitting light to the film. The second blind follows immediately behind it, controlling the length of exposure by means of the size of the gap between the blinds.

the light path, held there for as long as required, and then snapped shut again.

The simplest form of shutter, used in most cheap pocket cameras, is the sector shutter, a crude metal plate mounted immediately behind the lens. A rather more sophisticated design, capable of a wider range of speeds, is the leaf shutter, which is usually built into the lens, nestling between the glass elements. A series of metal blades, interleaved in much the same way as in a variable aperture mechanism, can be folded back out of the way of the light for as long as required and then snapped closed. One of the major disadvantages of these leaf shutters is their inability to react much faster than $\frac{1}{500}$th-of-a-second, which may not sound too disastrous at first but compares quite badly with the $\frac{1}{2000}$th-of-a-second possible with other systems.

A more serious problem is the leaf shutter's positioning within the lens, which means that it can only block out the light for as long as the lens is attached to the camera body. If you have to remove the lens whilst the camera is still loaded (to exchange it for another lens of a different focal length, for instance), a separate means of preventing light from reaching the film is required.

On the whole, leaf shutters are restricted to the more basic cameras, in which lens interchangeability is not an option, and most modern SLRs utilize the sophisticated focal plane mechanism. The focal plane shutter, which consists of two overlapping movable blinds, is mounted immediately in front of the film on the focal plane (the precise point at which light rays are brought into sharp focus by the lens).

In addition to overcoming the problem of changing lenses, this design has the advantage of keeping the shutter well away from the lens, allowing the SLR to give an accurate picture of what the lens sees without risking any premature exposure of the film. The two blinds, made from either metal or rubberized cloth, operate independently, with the length of exposure being determined by the time that elapses between the first blind opening and the second one closing. Faster speeds are possible due to the fact that both blinds move in only one direction, and the whole mechanism is automatically reset when the film is wound on ready for the next exposure.

But to describe shutters in purely mechanical terms is to ignore their considerable potential for affecting the type of picture the camera produces. By adjusting the shutter-speed control, exposures as short as ½₀₀₀th-of-a-second and as long as 2 seconds can be measured off automatically, accurately controlling just how much of reality is captured on film. Consider a photograph of a footballer in action, for instance. With careful timing and a shutter speed of ½₀₀₀th the result will be a frozen record of the very moment when boot and ball connect. At two seconds, on the other hand, provided the camera is held rock steady, the result will be a fluid image of the entire movement—including both the footballer's approach to the ball and its path thereafter.

With aperture-priority automatic cameras, which allow the photographer to choose the aperture he wants (the camera's metering system automatically provides the required length of exposure), shutter speeds are infinitely flexible. Most cameras indicate the choice of speed in the viewfinder, where a needle flickers up and down across a continuous scale, which I assume explains why photographs in camera magazines are no longer accompanied by captions like 'Kodachrome 25, f8 at 125th'. Very few cameras are equipped to provide the information that they have decided on an exposure of a 147th-of-a-second rather than a 146th or a 148th, and the result should be that attention is now concentrated where it belongs, on the picture itself rather than the technique behind it.

As variable speed settings begin to replace the old click stops of ⅓₀th, ⅟₆₀th, ⅟₁₂₅th and

A series of bracketed shots of the same scene showing the effects of different exposures. Under-exposed shots receive less light and are darker, over-exposed shots receive too much light and are bleached out. Note how exposure affects colour values as well as density.

so on, I cannot help wondering how long it will be before some bright manufacturer decided to go decimal, replacing ⅟₁₂₅th of a second with 0.008 seconds—a possibility that hardly bears thinking about.

However, the complexities of shutter-speed terminology pale into insignificance beside the technical terms associated with the other half of the exposure equation. Like the shutter, the diaphragm exists for the purpose of adjusting the amount of light, and again the basic idea is very simple: a series of thin metal leaves are interwoven in such a way as to

provide a choice of apertures of varying diameters. Turning the aperture-control ring one way opens up the leaves to provide a large-diameter hole through which light can flood on to the film. Twisting it in the other direction closes the aperture down to a mere pinhole.

The best way I know of appreciating the difference between shutters and apertures is by the time-honoured metaphor of bucket and tap, or faucet. The length of time required to fill the bucket depends on the rate at which the water is coming out of the tap. With the tap full on (large aperture) the bucket needs to be held under the tap only for a short time (brief exposure). But if the tap is turned down to a mere dribble (small aperture) the bucket must be held in place for much longer (long exposure).

The metaphor can be extended further to equate the size of the bucket with the sensitiv-

ity of the film, and the mains pressure behind the tap with the efficiency of the lens, but the most important thing to remember is that in this case we are filling the bucket in the dark. There is no way of knowing when a film has had sufficient exposure unless everything is carefully measured before we start.

And the complications start to multiply when we consider the units of measurement associated with that process. Shutter-speed measurement is fairly straightforward once you have grasped the fact that speeds such as 1/250th-of-a-second are usually referred to simply as a 250th. Measuring apertures is a different story entirely. At first sight it would seem that the easiest way of differentiating between one aperture and another would be to refer to the actual diameter of the hole. This would be perfectly adequate if we restricted

ourselves to just one lens, but ignores the fact that different lenses transmit different amounts of light. A 'long' lens, in which light has to travel further between one end of the lens and the other, produces much less light than a 'wide' one. And going back to our bucket and tap metaphor, the weaker the mains pressure the more fully open the tap needs to be; a long lens will require a wider aperture if it is to transmit as much light as a wide one.

Rather than introduce a third variable into the exposure equation to take account of different lenses, aperture measuring scales are therefore designed to measure the total amount of light rather than the physical dimensions of the aperture itself.

The units of measurement for this are called f stops, and commonly range from somewhere around f2 through f4, f5.6, f8 and f11 up to f16 or higher. Like most people I laboured under the illusion that the 'f' stood for 'focus' or 'focal plane' until I discovered that it actually stands for 'factor'. But what really confused me when I started to explore the intricacies of aperture settings was the way in which the various steps are chosen, and the fact that the f stop number increases as the size of the diaphragm opening decreases, f16 being a much smaller aperture than f2.

For a long time I contented myself with remembering that the more light there was in a subject the higher the f stop required to control it, but then I discovered the reasoning behind the system and everything became much clearer. F stops are calculated by dividing the focal length of the lens by the effective diameter of the aperture, and each increase in f stop produces precisely half as much light. F16 gives half as much light as f11, which gives half as much as f8, and so on.

By calibrating the f stops in this way the co-ordination of aperture and shutter settings becomes much easier, because they then have a one-to-one relationship. With every increase in shutter speed producing twice as much light (1/60th is twice as fast as 1/30th, etc.), an increase in either part of the exposure equation can be precisely matched by a decrease in the other.

So, when an exposure of f11 at 1/60th is indicated, a photograph will be just as adequately exposed at f16 and 1/30th—the tap has been turned down but the bucket has to be held

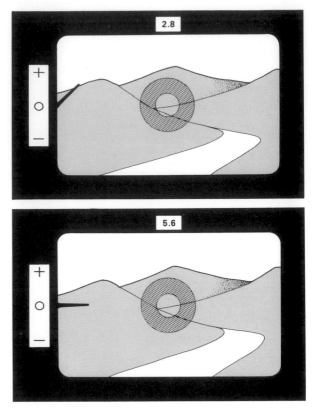

Matched needle displays housed in the viewfinder indicate the degree of over- or under-exposure. An aperture setting of f2.8 would result in an over-exposed photograph (**top**); f5.6 is correct (**above**).

in place for a little longer. An easier way to think about it is simply to remember that that whatever you do to the f stop number must be done in reverse to the shutter speed number— if you choose to go *down* to f8 you must remember to go *up* to 1/125th, and vice versa.

Photographs made with any of these three combinations of settings will all be exposed correctly but they will not appear identical because, like the shutter, the diaphragm produces different effects depending on which aperture is selected. Let us assume, for the sake of argument, that you have been asked to take some photographs of a girl walking by a river. You have chosen the model, checked out the location, and you have already got some idea of how you want the various elements in the picture to relate to each other.

When it comes to actually taking the photographs the first thing you will probably want to do is to check on how things look when framed by the edges of the viewfinder. At this stage the SLR's ability to produce a totally

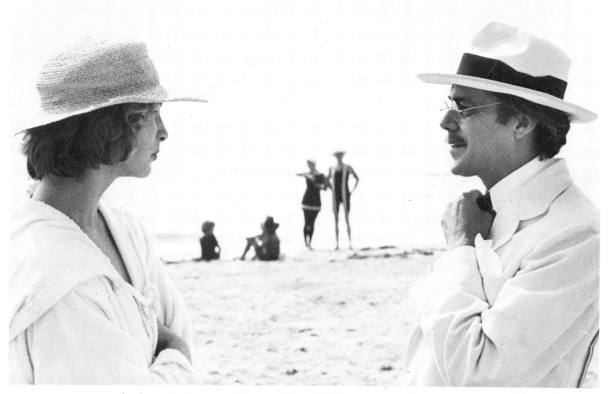

accurate picture of what the lens itself sees will be an advantage, but it will not be essential—unless, of course, you have got something like a gasworks in the distance and you want to be totally sure that it will not feature in the finished photograph.

A single-lens-reflex will help considerably, however, when it comes to focusing. Range-finders, which indicate distances correctly when two overlapping images come together, are accurate but can be fiddly to operate, even when coupled directly to the camera controls. And of course, judging the distance between camera and subject by sheer guesswork is not going to be reliable.

In an SLR the light entering the lens is deflected by a mirror set at 45 degrees up in the top of the camera, where a five-sided glass prism turns the image round the right way and projects it on to a ground glass screen; the lens can then be rotated until the main subject appears correctly focused in the viewfinder. Fine tuning of the focus is further assisted by various optical devices built into the view-finder screen.

A fresnel lens, which helps to conserve as much of the incoming light as possible, improves the overall brightness of the image and

Dirk Bogarde and Bjorn Andresen on the set for Visconti's *Death in Venice*. Careful use of depth of field has improved the composition by reducing the extras in the background to an unobtrusive blur.

is usually combined with a circular array of microprisms which give a distinctive shimmering effect on textured surfaces for as long as the image is out of focus. In many cases this ring of microprisms surrounds a central split-image spot, which breaks straight lines in the image into two offset lines that draw closer together as the lens is rotated closer to the correct setting. Some of the more expensive SLRs offer interchangeable viewfinder screens which allow you to select the focusing method best suited to your subject, but in most cases the standard screen will be more than adequate.

With the lens focused correctly on the girl, the lens is now positioned at exactly the right distance from the film to catch the light rays reflected from her and bend them back to form a sharp image at the focal plane, where the film sits patiently waiting to be exposed.

Light rays reflected from the river behind the girl are also being picked up but because they are further away they are focused not at the focal plane but somewhere behind it. Simi-

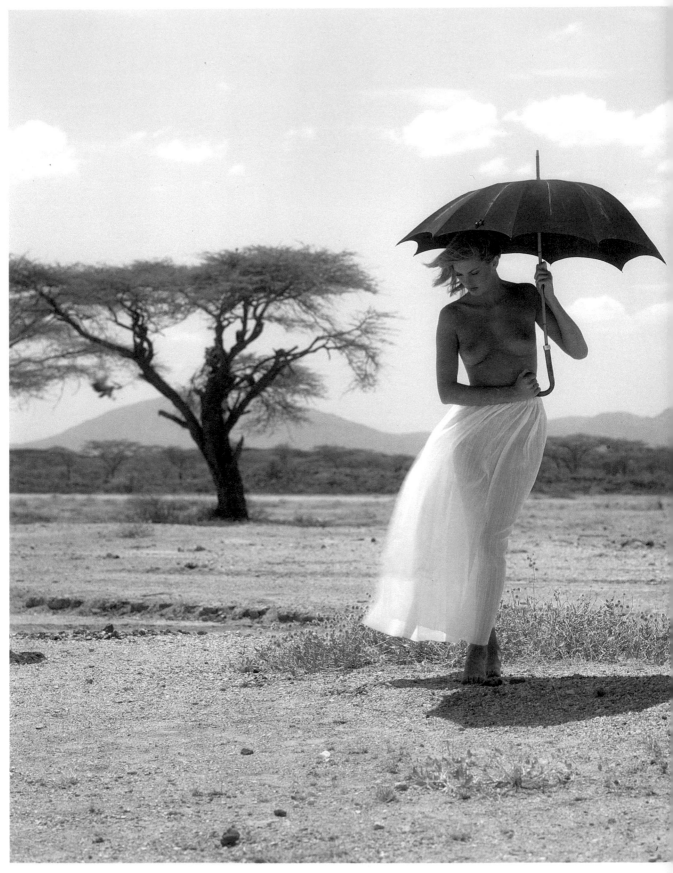

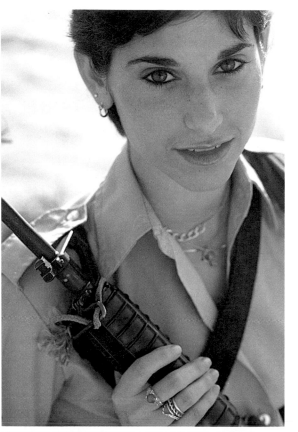

These pictures typify situations in which automatic metering may not be sufficient. Backlit subjects such as the Israeli soldier (**left**) and the girl in a cornfield (**below**) and strongly shaded subjects like the model with a parasol (**opposite**) will need an extra stop or two if they are to be correctly exposed.

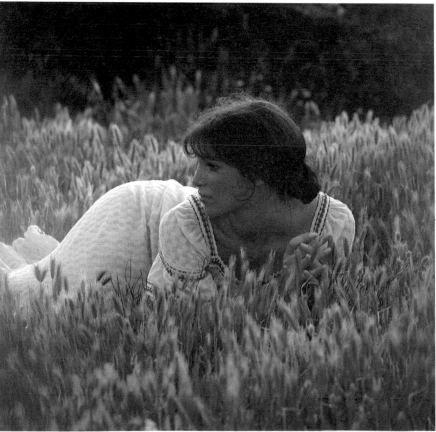

larly the image of the grass in front of the girl is only in sharp focus at a hypothetical place somewhere in front of the film, coming to a sharp point and then diverging again.

If the girl happens to be looking towards the camera you will have the opportunity of focusing on her most important features (photographically speaking). These are the catchlights—the two sharp points of light where her eyes reflect the sun. In theory only these two points of light, and anything else that happens to be in exactly the same plane, will be correctly focused, while everything else forms a soft blur, made up of the so called 'circles of confusion', in which the unfocused light rays intersect the focal plane without being brought to a point. (These circles grow larger as the distance from the main subject increases, and one of the best ways to observe the phenomenon is by moving a very long 'mirror' lens in and out of focus whilst pointing it at something like the sea, in which thousands of tiny highlights are reflected back towards the camera as circles.)

In practice, however, there is a limit to the human eye's ability to differentiate between a sharp point and a very small circle of confusion—at a normal viewing distance any circles of confusion of less than $\frac{1}{100}$th-of-an-inch across on the final picture will still be read as sharp points. So in fact most of the girl will appear to be in focus, together with some of the surrounding scene. Just how much of the river behind her and the grass in front of her appear sharp depends on the aperture selected.

As the diaphragm edges further and further into the path of the light through the lens it cuts down on the number of peripheral rays transmitted and reduces the size of the resulting circles of confusion. As more and more of these circles shrink below the critical $\frac{1}{100}$th-of-an-inch the depth of field that appears acceptably sharp grows deeper, spreading forwards and backwards from the main subject. If the controls are set to f2 at $\frac{1}{500}$th, the resulting photograph will inevitably concentrate attention on the sharply focused girl standing amidst the blur of the surrounding scenery. If you stop down to f16 at $\frac{1}{15}$th (using a tripod to keep the camera steady), you should produce a radically different picture with pin-sharp results across the whole field of vision.

The photograph on page 33 would, at first, appear to have nothing to do with depth of field. But as well as being affected by aperture the depth of field alters drastically as the subject comes closer to the camera, and in this instance it was only with the aid of powerful studio lights that I was able to use the tight aperture I needed to make sure all of the picture was sharply focused.

Once you understand the basic principles involved in the diaphragm's ability to manipulate depth of field (and they are not called circles of confusion for nothing), you will be able to use it as an extremely effective method of controlling the appearance of your photographs. When I found myself on the set of the film *Death in Venice* I was lucky enough to spot what looked like a classic photograph forming itself before my eyes. Although they were only making desultory conversation between takes, Bjorn Andresen's apparent lack of interest in Dirk Bogarde's conversation exactly mirrored their relationship within the film. The only problem was a noisy group of extras positioned exactly where they would do the maximum damage to the kind of composition I had in mind. With only a few seconds to spare before the cameras began to roll there was only one option open to me. Though the bright sunlight meant that I would be in danger of coming up against the camera's maximum shutter speed I opened the aperture right up and focused on the actors. The result, as you can see, was to limit the depth of field sufficiently to reduce the figures in the background to mere silhouettes, still recognizable as human figures but blurred enough not to offer any competition to the real subject photograph.

This picture also serves as a good example of the kind of photograph in which built-in automatic light metering systems see things differently from the photographer. Semi-automatic cameras measure the light values of a subject as reflected in the reflex mirror and compare it with the shutter speed and aperture selected on the camera. In theory, correct exposures can then be produced by adjusting the settings until the moving meter needle seen in the viewfinder stops in the right position.

In fully automatic aperture-priority systems the metering system itself selects the shutter speed required to match the chosen aper-

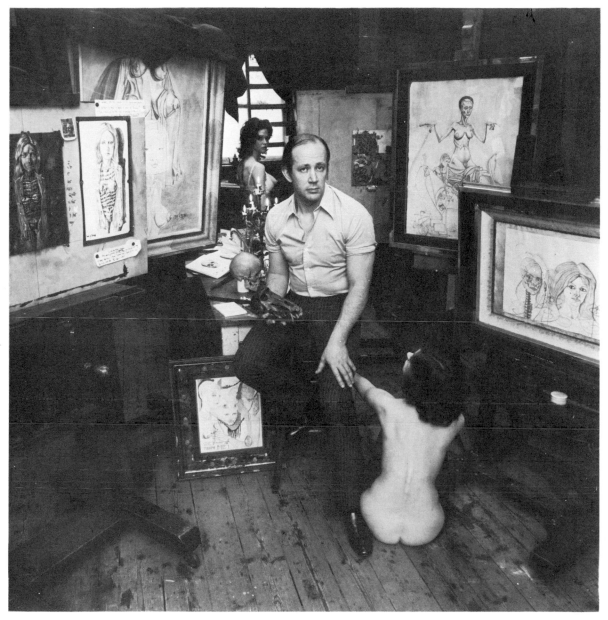

ture, courteously indicating its choice in the viewfinder window, either with a needle or with a series of light-emitting diodes. The more sophisticated of these measure light values from the film plane rather than the mirror and can therefore adjust themselves to rapidly changing light conditions, even during the brief moment when the mirror snaps out of the way to allow light through on to the film.

The rather rarer shutter-priority systems work in much the same way but adjust the aperture to match the shutter speed selected, and a new generation of cameras that offers a choice between the two systems is now coming on to the market.

Here, the light levels vary from strong (the full light of the window) to dark (below the easels), each requiring a different combination of exposure values. To focus attention on the artist, Louis de Wett, the window has been bleached out and shadow areas obscured.

All of these different options suffer from one common failing, the inability to react to anything other than predictably composed images. With rare exceptions, every potential subject consists of a range of different objects, each one of which reflects light in a different way. The correct exposure for one part of the picture is therefore often wildly different from that needed in another and, unlike a photo-

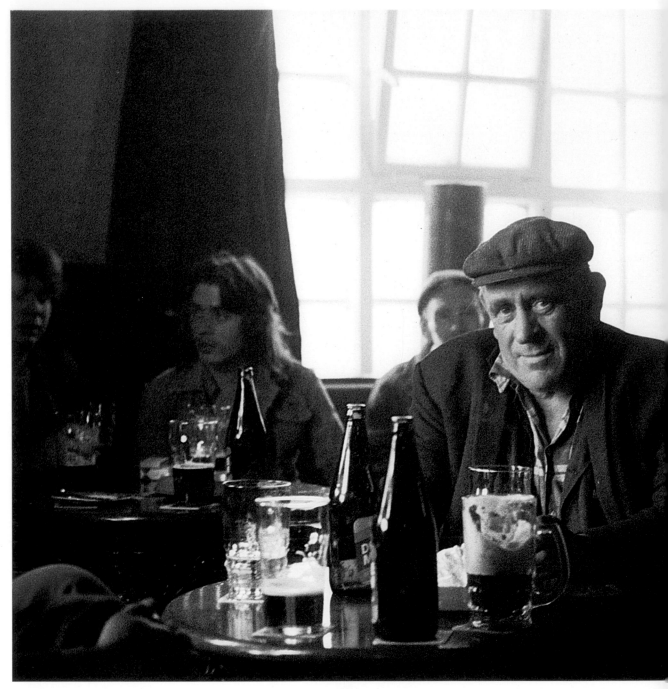

grapher armed with an independent light meter like the Weston, a camera's metering system is in no position to decide which part of the picture is the most important—it has to apply the same criteria to every picture it sees.

Some systems weigh up all the different exposure values and produce an average reading across the whole scene; this works quite well except in situations such as that on page 40, in which the bright African sunshine would swamp the girl's shaded face.

Other systems measure only the central area of the image, underestimating the photographer's creativity by assuming that the most important part of the composition will always be placed dead centre. The best and, to be fair, the most common, compromise is the centre-weighted system which places most of the emphasis on the central area but also takes the periphery into account. Unfortunately this method, like the others, would be totally thrown by the *Death in Venice* picture, in

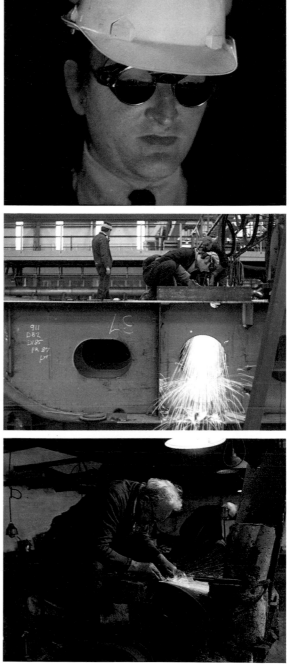

Around the Sunderland shipyards. Despite the bright light behind him, I needed a slow shutter speed for the men in the pub (**left**) and for the man welding (**top**). The more distant shots needed faster speeds to stop the sparks blurring.

which the main subjects are positioned at the edges of the frame.

Strong backlighting, as seen in the pictures on page 41, tends to feature quite heavily in my photographs, which means I usually have to override the automatic metering system, opening up by at least one stop to obtain sufficient detail in the skin tones. With very dark subjects and in situations where the backlighting is particularly harsh, like the scene photographed in the Sunderland pub, I may even have to open up still further possibly by as much as three stops.

In other situations the controls may have to be adjusted to restrict the amount of light. Although the portrait of the man welding (above) required an exposure so slow that the

Above James Coburn emphasized against a bleached-out background on the set for *Duffy*. The picture was taken over the obliging shoulder of Susannah York. **Right** A backlit shot of Dean Martin.

colour balance of the film has begun to be affected, the longer shots required much shorter exposures.

The final picture illustrates that there is one more ingredient in the recipe that is more important than either photographer or camera— good old-fashioned luck. Driving through the Hollywood Hills on the way to a portrait session with Dean Martin. I planned to pose him with his favourite possession, but I arrived to find him alone in an empty house. Not wanting to ask what had happened to his worldly goods, I persevered with my plan hoping that he had managed to hang on to at least one thing that he cared for.

As you can see, my instincts were correct. He had managed to keep by him all he needed to mix himself a very large, very dry martini.

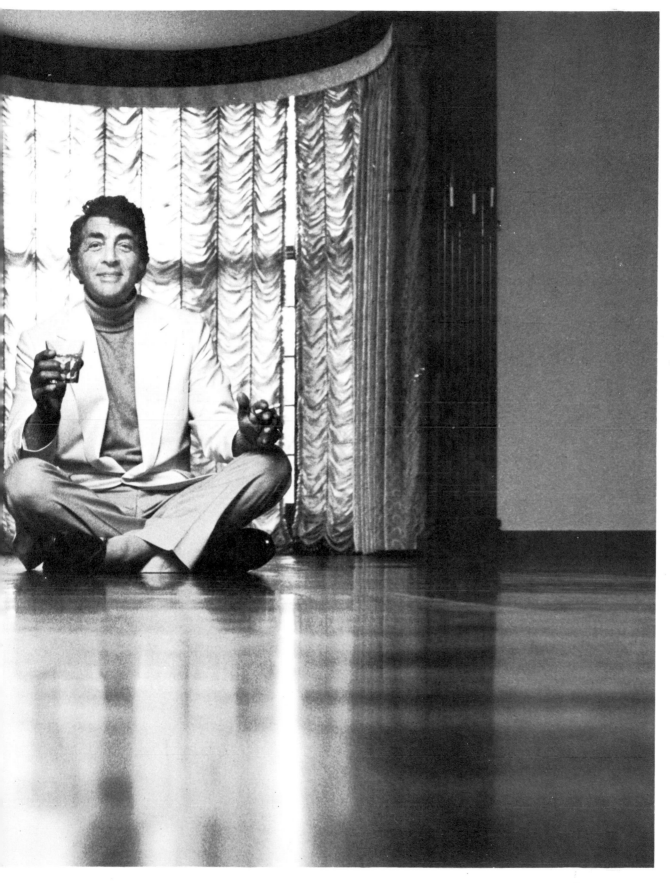

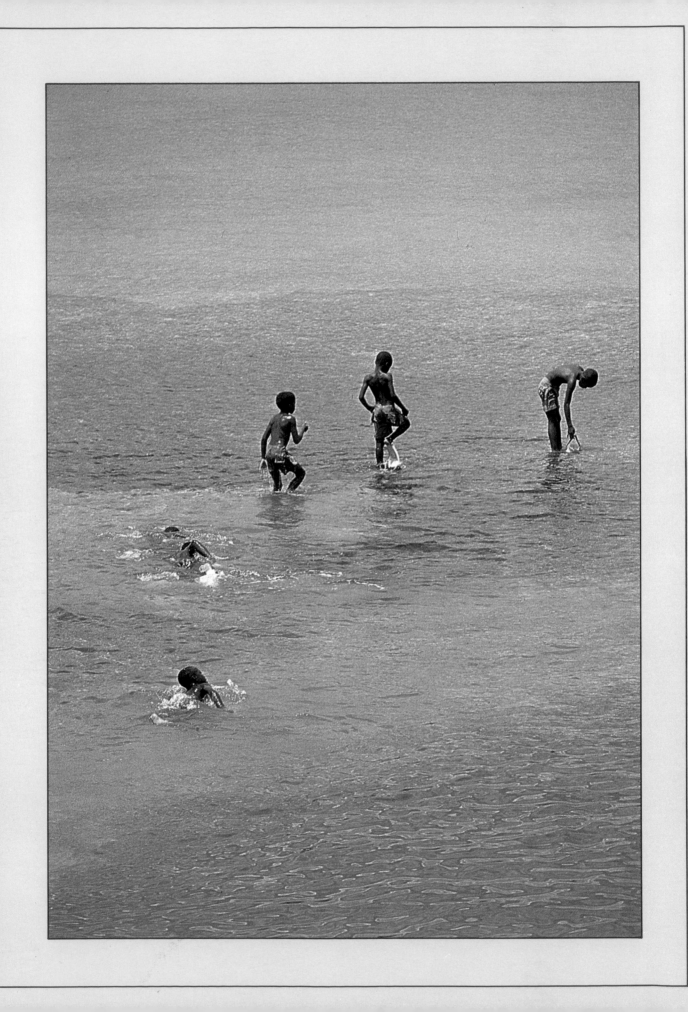

3
A SENSE OF PERSPECTIVE

It has always struck me as strange that a medium as flexible as photography seems to give rise to some of the most jaded clichés imaginable. 'Creative' is one, a word that more often than not seems to be just another synonym for gimmicky, especially when used in advertising copy. More subtle, but more dangerous, are the constant comparisons that are drawn between a camera lens and the human eye.

There is, in fact, very little similarity between the two. The human eye does not rely on a number of interrelated glass elements, nor does it deal in frozen segments of time, and it does not produce equally sharp results across the whole picture plane. The way my eyes saw the West Indian boys playing in the sea was considerably different from the way my telephoto lens pictured them. I saw the boys only as part of the overall panorama: it was the lens that isolated the final frame . . .

Any photographer, provided he is able to afford the not inconsiderable expense involved, can now equip himself with a range of lenses capable of providing him with pictures of the smallest seashell and the largest oil tanker, all without moving the camera. Macro lenses can fill the frame with the petals of a petunia, shift lenses can easily correct converging verticals, fisheye lenses can cover a field of vision that extends at 180 degrees from the camera—and each and every part of these images will be pin-sharp and completely free from distortion, thanks to the precision engineering that most of us take for granted.

One of the earliest true innovators in the field of lens design was an Austrian scientist called Josef Petzval. Amazingly enough, he had never applied himself to the subject before he produced his successful design for a new lens in 1840. The popularity of the lens, which remained a best-seller right into the first half of this century, was undoubtedly due to the fact that Petzval was the first designer to calculate the effects of his lens mathematically before he began work on it.

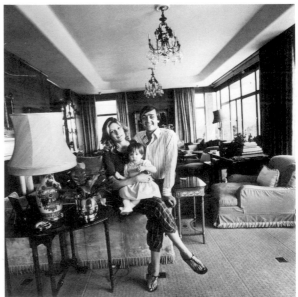

Today's designers use computers and laser technology in a constant search for improvements, but the basic rationale remains the same: light waves travel more slowly through glass than they do through air.

A concave lens, the curved sides of which 'cave' in towards the middle, has more glass at

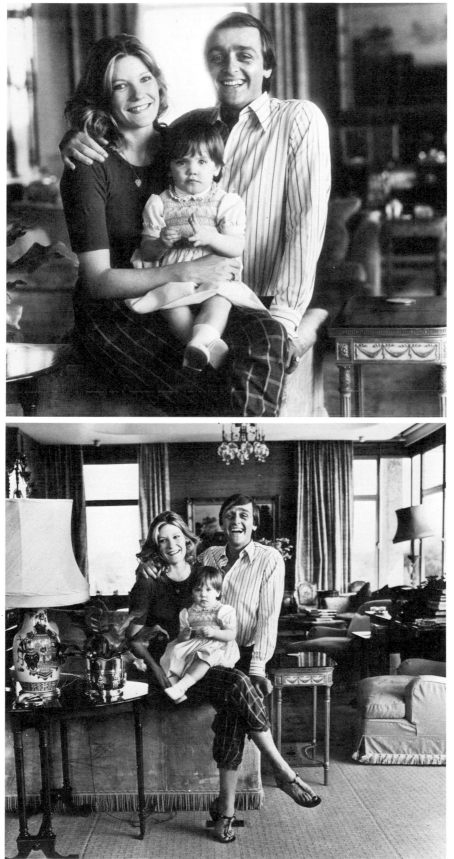

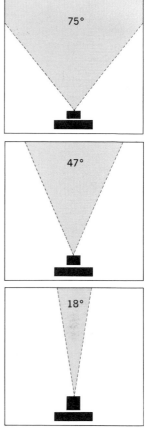

Most SLRs can be fitted with a variety of interchangeable lenses to produce different points of view. **Below left** The Duke and Duchess of Westminster seen through a 135mm lens which gives an angle of view of 18 degrees; **above left**, through a 50mm lens with a 47-degree angle of view; and **far left**, a 28mm lens, 75 degrees.

Overleaf A wide-angle shot that owes its effect partly to the focal length of the lens, partly to luck. The shutter jammed open during exposure, producing a series of blurred streaks as the film was wound on.

its edges than it does at the centre. Peripheral light rays therefore move more slowly than those that pass through the centre, and the result is a spread of light. Convex lenses, the sides of which curve outwards, have more glass in the middle and therefore bring light rays to a tight focus.

When I was a schoolboy at Harrow one of our longest-lasting preoccupations was the possibility of starting a fire with a magnifying glass, a craze that came to an end only when a master discovered my Latin textbook decorated with a fringe of brown scorch-marks. Although I did not realize it at the time this was an early example of an enduring preoccupation with lenses, in this case a convex lens that concentrated the heat rays from the sun into one small smouldering point in much the same way as a camera lens bends light rays in order to converge them on to the focal plane.

Had I stopped to use the magnifying glass for its proper purpose, I would also have had a good illustration of the principles of focal length as I manoeuvred it up and down to find the correct distance at which the enlarged image came into sharp focus.

The more curved the sides of a lens, the shorter the distance required between lens and subject; almost spherical lenses possess very short focal lengths, and vice versa.

The same principles hold true in photographic lenses, different focal lengths producing different effects. An average wide-angle lens with an angle of view of approximately 75 degrees has a short focal length, somewhere around 28mm. A 'long' lens—which, like a telescope, brings distant subjects closer—has a much longer focal length, anything from 135mm up to 400mm or more.

Unfortunately for lens-designers the days when a lens consisted of just one curved glass element are long gone. Even Petzval's lens used at least four individually shaped pieces of glass (crown glass and flint glass), taking advantage of the fact that light travels at different speeds through different types of glass.

Modern lenses can consist of up to twenty separate elements spaced out along the barrel, many of them made from the so-called 'rare-earth' glass types which contain trace elements of materials such as barium.

Some of these elements are there for con-venience rather than efficiency, folding the light path up inside the lens in an attempt to minimize the overall weight of long-focal-length lenses, or extending it to allow room for the complex mirror mechanism between the back of the lens and the film. Other elements have to be introduced to correct the distortions inherent in such complex optical designs.

Chromatic aberration, the most obvious of these distortions, produces multi-coloured fringes around otherwise distinct subjects where the various wavelengths that make up 'white' light come to a point at slightly different places thanks to the slight variations in their speed.

Another problem is coma, a series of circular patches of light formed at the edges of the picture; astigmatism is the inability to bring both vertical and horizontal lines into focus in the same plane.

Spherical aberration produces loss of image definition and barrel and pincushion distortions make otherwise straight lines appear as if they were curved. Still more elements have to be introduced to produce a flat field of focus because a curved lens, naturally enough, tends to form itself as a curve unless corrected.

Because so many elements are needed to produce a sharp, evenly illuminated image that is completely free from distortion, lenses tend to be heavy, and the last thing a photographer wants when he is working out on location is a slipped disc caused by the weight of the four or five lenses he may need to carry in order to cover all the possibilities.

Zoom lenses, with their ability to span the focal lengths of two or three fixed lenses as well as everything in between, can justifiably claim to be the single most important advance in lens design this century. Despite the complexities inherent in their design, the quality of image that they produce is now beginning to be virtually indistinguishable from the relatively simple fixed-focus lenses which I suspect they will eventually replace.

A recent report in a photographic magazine announced the launch of the latest development: a one-touch zoom that offered a range of focal lengths from 8mm up to 400mm with outstanding image quality—all for under £200. My heart leapt, and I reached for the studio order book. Then I noticed the

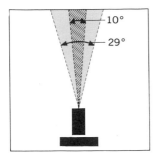

Above Zoom lenses offer a range of focal lengths (in this case from 85mm to 250mm), selected simply by rotating the barrel. This means that flexibility is increased and special effects such as this (**right**) are possible.

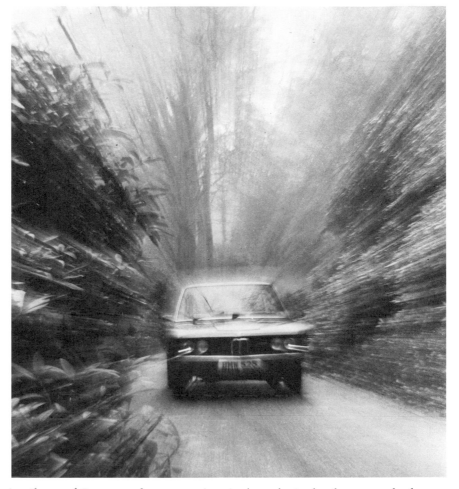

magazine's dateline—1 April—and I returned to reality with a bump. To cover every eventuality, photographers still need at least two different zooms, say 28 to 85mm and 80 to 200mm, but the advantages are tremendous. Rather than trying to work out the composition he wants and then searching for a lens to match it, he can adjust the framing as he goes, simply twisting the lens barrel to bring the subject closer or to move it further away. Most of the magazines I work for prefer me to supply them with transparencies, so I tend to have less flexibility when it comes to cropping the final photograph; you cannot take a slide into the darkroom and choose which particular part of the image you want to feature, as you can with a black-and-white print. With a zoom lens on the camera I can choose the focal length I need in order to include or exclude as much of the view as I require, and if it takes something as specific as 93.5mm I can have it.

The main disadvantage, beyond the fact that zoom lenses tend to be heavier and more expensive, is the relatively slow speed of most zooms. All lenses lose light as they transmit it from one end of the barrel to the other, and the complex design needed to provide a variable focal length inevitably affects the amount of light that a zoom projects on to the film. The result is a restriction of the maximum aperture possible, which tends to be one or two stops higher than that of a comparable lens with a fixed focal length—say, f2.8 rather than f2.

Another disadvantage, psychological rather than physical, is that zooms tend to make a photographer lazy, simply standing in one place and manipulating the composition by zooming in and out rather than constantly keeping on the move in search of a better angle on his subject. Against that I would set their ability to create

Overleaf, left The Eiffel Tower at night as only a zoom lens can show it.
Right A long lens brings distant subjects closer. Nobody was more surprised than me when a cry for more film flushed these two lovers out of the distant undergrowth.

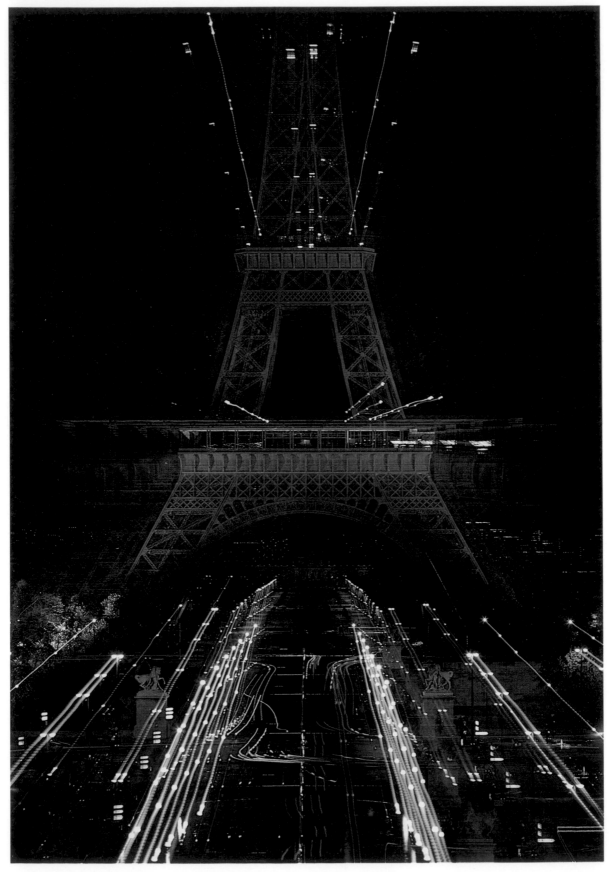

shots like that shown on page 55, where I have used the lens to track a moving car during a longish exposure, producing a sharp image of the moving vehicle against a dramatically distorted background. Although the result gives the impression of great speed the car was in fact moving quite slowly—adjusting focus on a moving subject is difficult enough without extra problems.

If you already own a zoom lens, or can borrow one from a wealthy friend, you will be particularly well equipped to observe one of the main features associated with changes in focal length: the way in which the appearance of a photograph changes as you move from one focal length to another.

Position yourself in such a way as to include the view through a window in the scene you see in the viewfinder, twisting the lens barrel so as to increase or decrease the effective focal length. It may at first appear that the view is changing in exactly the same way as when you yourself move closer to the window: distant objects grow larger, filling more and more of the frame and providing greater detail.

But take another look, this time concentrating on the portion of the world outside framed by the edges of the window. Unlike what happens when you walk across the room towards the window, the view through the window remains exactly the same no matter which focal length you choose—you do not see more of it as the window frame looms larger.

So the first thing to note is that changing lenses does not affect the relationship between the various objects that make up the picture. All that happens is that a long lens sees a smaller section of reality than we are used to, and a wide lens sees more. But there is no doubt that the choice of lens affects the look of a picture in one way or another. We have all seen photographs taken with wide-angle lenses in which a perfectly normal face looks utterly grotesque, with the nose apparently ten times the size of the ears. And at the other end of the scale there are those classic cricket action shots (some readers may feel that this is a contradiction in terms) in which the bowler looks as if he is only inches away from the batsman.

The fault, surprisingly enough, lies not in the lens but in the human eye or, more accurately, in the human brain.

Despite our ability to vary our attention from nearby objects to distant ones we are used to a fixed perspective. We are not surprised when railway lines appear to converge as they reach towards the horizon. And we are used to the relationships of scale that are associated with that perspective: we are equally unsurprised when two horizontal sleepers close to us appear to be widely separated whilst a distant pair seem almost to touch.

But when we look at two photographs of the same railway line taken on a wide-angle lens and on a telephoto respectively we expect those rules of perspective still to apply, and we are faintly uneasy when they do not. The telephoto shot isolates a distant section of the track in which the sleepers appear crowded together—not what we except when we are looking at the scene from a normal viewing distance. And a wide-angle lens shows us sleepers that seem more widely spaced than normal, which is equally disorienting.

If we want to correct this feeling of disorientation the only way to do it is to change the distance from which we look at the photographs. The wide-angle shot will appear perfectly normal when viewed from a few inches away; the telephoto shot should appear equally ordinary if seen from the other side of the room. Changing the viewing distance in this way helps to re-establish a proper relationship between the photographs and the way in which we normally look at the world. The wide-angle picture expands to fill the entire field of vision whilst the section of reality seen through the long-focus lens shrinks back to assume its proper place as just a part of the overall view.

Observing pictures in this way also counteracts another kind of distortion introduced by very long and very short lenses: the way in which the depth of field alters. Even when set to the same aperture, a long lens will always give a much shallower depth of field than a wide one (all other things being equal). When focused on a point some ten feet away from the camera and set to an average aperture, say f5.6, the depth of field on a wide-angle 28mm lens will stretch from about six feet from the camera right out to the horizon and beyond.

A 50mm lens will produce sharp results everywhere between eight and thirteen feet

Fisheye lenses cover an extremely wide angle of view. They produce startling effects but need to be used with discretion.

away, and a long 135mm lens will give only a very shallow depth of field, extending barely four inches in front of the ten-foot line and only eight inches behind it. (Depth of field always extends further back than it does forwards, in a ratio of two to one.)

But remember, depth of field is always relative. Close examination of a print will reveal that the small circles of confusion that previously appeared to be sharp are actually out of focus, whilst viewing it from a distance will have the opposite effect.

You should be able to get some idea of the way that changes in viewing distance affect our perception of perspective and depth of field by trying the technique out on some of the photographs in this book. But please do not make a habit of it: I chose these different lenses for a purpose. A good photographer never allows distortions of perspective to creep into his photographs by accident.

The exception that proves the rule is the photograph on page 57. Here, the primary appeal of the picture lies in its unabashed voyeurism rather than in its foreshortened perspective and shallow depth of field.

As part of a series of photographs we were shooting in and around my old school, Harrow, we set up our equipment on the edge of a field in which I knew horseriders from a nearby riding school could usually be expected to put in an appearance at about noon. I was particularly pleased with the location, an oasis of calm tucked away only minutes from a major arterial road. When I checked the view through the viewfinder, the long lens on the camera revealed that I was not the only person in on the secret, for just then two lovers popped up out of the grass.

As well as being yet another reminder of the importance of luck to a photographer, the picture is a telling example of the power of long lenses. A 'standard' lens would have given me only a picture of a large green field with traffic passing by on one side and two vague pink dots on the other.

There are two schools of thought as to why the standard lens is so called. Most people will tell you that it is because these lenses closely replicate the way in which the human eye perceives the world—an angle of view of approximately 45 degrees, a familiar perspective, and an adequate but not over-wide depth of field. Personally I tend towards the paranoid interpretation (that a standard lens is the one most camera retailers have decided to sell people who are buying their first camera).

The focal length of a standard lens always approximates to the diagonal dimension of the film format used in the camera, which on a 35mm SLR is 43mm. On a 2¼-inch-square camera, however, such as the famous Hassleblad, this would be a wide lens, whilst on one of the smaller pocket cameras it would be extremely long. To make life easier for everybody the focal lengths referred to throughout this book are the ones used on the most popular format, 35mm, for which the standard lens is, in practice, usually a 50 or 55mm.

Most of the professional photographers I know use a standard 50mm lens only occasionally. They tend to settle on something a little more distinctive that complements their own particular style. None the less, if you have not done much photography before and you are still uncertain as to which kind of lens to begin with, I would have no hesitation in recommending you to start off with a standard lens. Apart from anything else they are usually cheaper. Learning about the effects of different lenses is by no means the most important part of photography and with a standard lens you can concentrate on the basics before moving

up to another lens, which I would suggest should be some kind of medium-range zoom— wide-angle or telephoto.

Although I always try to remain as flexible as possible in my choice of lenses, I must admit to a sneaking preference for lenses that are just slightly longer than normal, the so-called 'portrait' lenses with focal lengths of somewhere between 85 and 135mm. I tend to do quite a lot of portrait photography and, as their name implies, these lenses are particularly well suited to that, enabling me to fill a frame with somebody's face without alarming them by appearing to stick the camera up their nose.

Portrait lenses, and any other lenses with a focal length of between 85 and 200mm, are usually referred to as telephotos. In fact the term 'telephoto' should be used only in reference to lenses that include some optical method of folding up the light path inside the camera, thereby producing a lens which is physically shorter than its designated focal length. But it is probably too late to reverse the trend by now. Lenses with focal lengths of over 200mm are called super-telephotos.

To be frank I tend to fight a little shy of these super-telephotos because of the problems they cause with camera shake. The longer the lens you are using, the more evident the effects of moving the camera during exposure, and with super-telephotos even the slightest vibration is enough to produce fuzzy pictures. A good rule to remember in conjunction with this point is that you should never attempt to hand-hold a camera at a shutter speed that is lower than the focal length of the lens you are using—do not go below ⅟₆₀th with a 50mm lens, or use less than ½₅₀th with a 200mm lens, and so on. (These are not firm rules, but are intended as a guide. Photographers with hangovers should apply a factor of × 2 or more, depending on the degree of overhang.)

The obvious solution to camera shake is to mount the camera on a good strong tripod, and most of the super-telephotos come equipped with a tripod socket on the lens itself, at the point where the considerable weight of the lens is accurately balanced by the weight of the camera. If you make sure that the tripod itself is firmly positioned, and hold the camera steady with both hands, you should never have to worry about camera shake, but you may

find that the camera is no longer as portable as you might like. A less reliable but more flexible answer is to wedge yourself firmly up against the nearest available upright and observe the two rules for pressing shutter buttons: always take the picture when your lungs are comfortably half-inflated; and squeeze, do not jab.

Other points to remember when using telephotos are their minimum apertures, which tend to be higher than on standard lenses, and their tendency to emphasize the amount of

Mirror lenses combine glass optics with mirrors to fold a long focal length up into more manageable proportions. The doughnut-shaped highlights occur only with this type of lens.

atmospheric haze between you and the subject, which can be minimized by always using them in conjunction with an ultraviolet (or 'sky-light') filter.

An expensive but highly appealing alternative to the usual telephoto design is the mirror, or catadioptric, lens (also referred to, wrongly, as 'catoptric'). Mirror lenses employ mirrors rather than glass elements to fold up the light path inside the lens, and the result is a much lighter, much more compact lens that can be handheld satisfactorily even at focal lengths of up to 600mm. Their major disadvantage is that, in contrast to conventional lens designs, there is no way that the diaphragm can be positioned in its normal place between the elements, and the result is that mirror lenses have

only one fixed aperture—usually f8, although it can be lower. The increased diameter of the front element of the lens also means that standard filters cannot be used; many designs now incorporate their own set of filters, which is built into the rear of the assembly.

Mirror lenses none the less represent an area in lens designs that will undoubtedly show rapid advances in the next few years. While you are saving up for one, watch out for the characteristic doughnut-shaped, out-of-focus highlights in other people's mirror lens shots (like the one on page 61).

As the focal length of a lens drops below the standard 50mm, the effects it produces increasingly tend to be the exact opposite of what happens with telephotos. The angle of view widens rather than narrows (75 degrees on a 28mm lens, 18 degrees on a 135mm), perspective opens up, depth of field increases and camera shake is all but eradicated.

The disadvantages also multiply: the range of f stops available becomes increasingly restricted, distortions become more and more noticeable and the technical terms multiply. (Again, there are both wide-angle lenses, and super wide-angle lenses; the equivalent of 'telephoto' is 'retro-focus', in which the optics of the lens increase the length of the light path to allow room for the various mechanisms the camera needs to fit in between the back of the lens and the film plane.)

Deciding whether to use a short- or long-focus lens is like trying to make up your mind between a good strong net and a high-powered rifle—and in both cases it depends on what you are trying to catch. Wide-angle lenses have a useful ability to introduce a sense of space into a photograph, they are particularly good at producing uncramped interior shots, and their depth of field means that you can take landscape pictures with sharp results across the whole field of vision, from flowers in the foreground right back to the hills on the horizon.

But in all cases you must watch out for distortions, particularly those that the eye tends to compensate for when it sees the picture in the viewfinder. All lenses produce converging verticals when pointed anywhere other than at the dead centre of a subject, but the effect is particularly noticeable with the wider-angle lenses: people shot from above look as if

they are sprouting up out of the ground, and buildings shot from below look as if they are about to topple over. There are two solutions. You can either use the distortion as an inherent part of the picture to give, for instance, images of skyscrapers that dwindle to nothing as they rise higher and higher, or you can invest in a more expensive shift lens.

Shift lenses are based on the obvious but often ignored fact that a circular lens produces circular pictures—the oblong image on a 35mm film is only part of what is perceived by the lens. Using the controls of the shift lens you can adjust the rectangular image in relation to the overall circular field of vision to select that part of the picture in which the vertical or horizontal lines are parallel to the sides of the frame—restoring 'falling' buildings with a single twist of the lens.

The picture on page 59 shows all the distortions inherent in wide-angle lenses multiplied to the nth degree—with a 'fisheye' lens.

These very short (8 to 16mm) lenses come in two basic types: one adjusts the image to stretch beyond the confines of the film, producing a rectangular picture, the other makes it shrink down within it, resulting in the far more characteristic circular picture. The only lines that will appear undistorted in a fisheye shot are those which pass directly through the centre of the picture: all the others will appear to be incredibly curved.

The name of the lens comes from what we assume to be the way in which a fish, looking upwards through the water, sees the world. However, in my opinion lenses should be part of the supporting cast, definitely not the star of the show. Distortions as marked as these totally negate any pictorial content in a photograph, reducing it to a mere visual gimmick, which is not what I understand to be the purpose of photography. For anything other than technical shots which actually need the horizon-to-horizon 180-degree view that these lenses provide, I am more than happy to leave fisheyes where they belong—on fish.

Like other lenses, wide-angle lenses often produce better pictures when the camera is held vertically rather than horizontally. This picture shows Merle Oberon with a collection of her favourite pictures (I am pleased to say that two of them are mine).

4
TWO-DIMENSIONAL REALITY

Although we tend to think of photography as something that is inextricably linked to cameras it is, in fact, quite possible to do without them. As Moholy-Nagy demonstrated in the 1920s, a series of three-dimensional objects placed on the surface of the emulsion itself and exposed directly to the light can produce extremely elegant images. These two-dimensional ghosts of everyday household objects bear little resemblance to the way we usually see things, yet they are still a type of 'photograph'.

The distant view of the London skyline shown on the opposite page owes as much to camera and lens as it does to the film, but it is the film which was ultimately responsible for retaining the image once the other mechanics had done their job. A camera without a film in it is like an expensive propelling pencil without a lead, attractive to look at, pleasant to hold in the hand but, ultimately, not much use to anyone.

As the early pioneers of photography realized, the true secret of making permanent records of reality lies in the film, not the camera. In fact it is probably true to say that the history of photography only began once the basic problems of fixing an immutable image were solved, setting off a long and often tortuous process of evolution that has led from the camera obscura through to the modern SLR.

The extremely dramatic improvements that have been made in camera design since then have inevitably attracted all the interest, concentrating attention on the ways in which light is transmitted to the focal plane rather than on what happens to it once it gets there. With the possible exception of Dr Edwin Land's Polaroid system, the story of film technology over the same period has been one of slow but steady progress, undramatic but none the less substantial.

In contrast to camera design, in which each new development has invariably made its predecessors redundant, the comparatively anonymous progress of film emulsions has resulted in a very broad range of film types, with each new improvement complementing, rather than superseding, the status quo.

As a result the photographer now has a wider choice when it comes to film stock than he does between cameras. The possibilities range from individual sheets of fine-grained black-and-white film for whole-plate cameras through to 36-exposure cassettes of high-speed 35 mm colour film, with a wide variety of shapes, sizes and, above all, speeds in between. All of these different films are based on the ability of silver halides to record patterns of light. 'Halides' is a generic term for all the various salts of silver that react to light: silver bromide, silver chloride, and, just as in Daguerre's time, silver iodide.

The shiny material that we tend to think of when we think of film is in fact acetate—the strong but flexible backing sheet that serves as a support for the emulsion itself—a thin layer (or 'film') of millions of tiny particles of silver halide suspended in transparent gelatin. (Traditionalists may care to note that gelatin is still made from the same material as it has always been: processed cow's cartilage.)

The brief flash of light that floods into the camera when the shutter snaps open produces

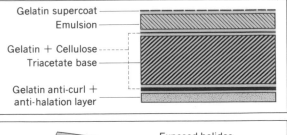

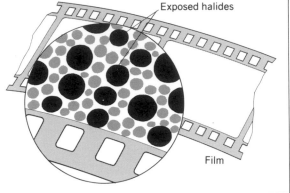

Top Light-sensitive particles of silver halide are held suspended in a thin 'film' of gelatin attached to a flexible acetate backing. **Above** Grain results as halides clump together during processing. Large particles react faster to light than small ones, therefore fast films tend to be grainier than slow ones. **Right** One of my assistants posing as a bewildered tourist on London Bridge. The low level of available light meant I had to use a fast film.

an irreversible change in the halides, which become chemically unstable wherever light strikes the film. Apparently physicists still have no satisfactory explanation as to why this reaction occurs (although I once heard what seems to be perfectly logical reasoning from a film technician I met: 'How would you react,' he said, 'if somebody carried you round in total darkness for weeks on end and then suddenly shone a bloody great light in your face?').

At this stage the reaction of the halides is a purely physical one with absolutely no visual effect whatsoever, as you can see if you have the money and time to waste pulling an exposed and an unexposed film out of their cans and comparing them. The light information caught by the film is carried as a 'latent image' which only becomes visible when the halides are exposed to the developing solution later on, changing them into particles of pure black metallic silver and creating a negative image which reads black for white and vice versa.

Most 'black and white' negatives actually

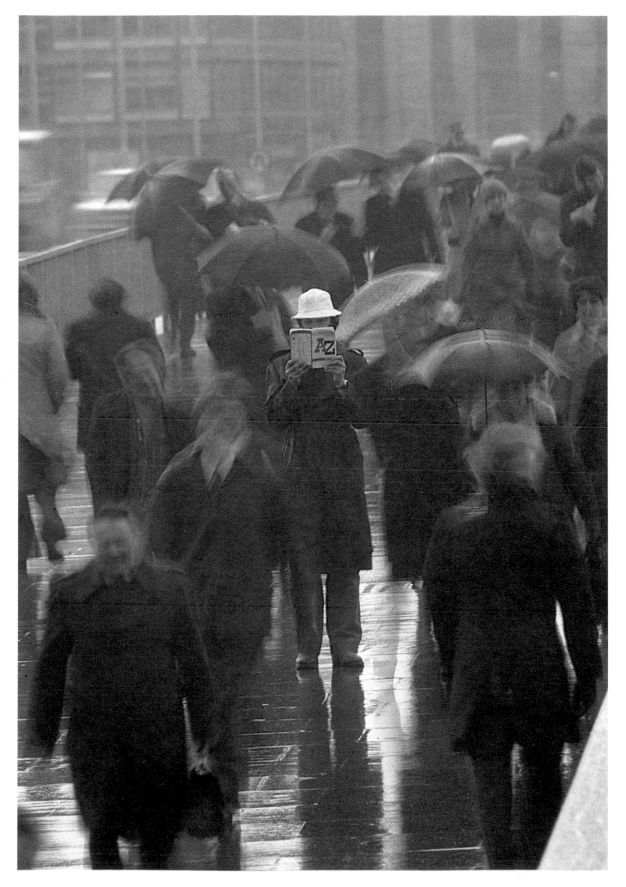

Pictures from a series on 'The Seven Ages of Man' showing the versatility of black and white films. Compare the grainy effects of the fast film used for the shot of father and son with the fine detail in the portrait of actor Harold Bennett.

consist of a wide range of shades of grey, which leads many people to the erroneous conclusion that halide conversion is some kind of gradual process, with the amount of light striking the film being in direct proportion to the degree of instability in each halide. In fact a halide is either affected by the light or is not—there is no in-between stage. The different tones produced depend only on the *number* of affected halides present, which in turn depends on their size (larger hallides require less light before changing than do small ones).

The pictures on these pages come from a series I did for Bayer Pharmaceuticals based on the Seven Ages of Man. Although they were shot on a variety of different films any one of them will serve as an illustration of how the basic process works.

Take the picture of the family group, for instance. A dark area, like the side of the dog's head, reflects very few light rays, affects only the largest of the silver halides and results in a correspondingly light area on the negative. A bright surface, say the walls of the house in the distance, reflect so much light that all the halides, both large and small, are affected and a dense, black image is formed on the negative. When the process is reversed at the print-making stage the black, negative image of the walls of the house lets very little light through the negative and hardly affects the printing paper at all, leaving it white. The dog's head, however, lets through a lot of light, producing a dark image in the final photograph.

Larger halides turn into larger particles of black metallic silver when they are exposed to

the developer, and the larger the particles the more they have a tendency to clump together to produce the characteristic grain pattern that is evident when a photograph is enlarged. A 'fast' film, one that has a greater proportion of large halides and a subsequently higher sensitivity to light, will therefore always produce a grainier result than a 'slow' film. There are two schools of thought regarding the desirability of pronounced grain in a photograph: which you favour depends on whether you think a photograph should be as close to reality as possible,

or prefer the very 'photographic' effect that comes with a grainy finish. Most of my work nowadays tends to consist of fashion, portrait and beauty shots for reproduction in glossy magazines and I usually find myself more preoccupied with the question of the film speed required than with that of the grain it produces. Whenever I can I like to work with as much light as possible so that I can use the slower films to obtain fine-grained pictures with a full range of tones and as much detail as possible. (The picture of actor Harold Bennett in the Seven Ages series is a good example of this kind of photograph.)

If I am covering a subject where I know the light might be a bit unreliable I make sure I have several rolls of something faster on hand and then do everything I can during the processing stage to keep grain to a minimum. But that is purely a matter of personal taste and I cannot advise you to do the same: the choice of film is one of the most effective ways there is to control the look of the finished photograph and you should never limit the possibilities unnecessarily.

In any case, the latest developments in film technology may well mean that the low-speed/fine-grain equation will soon become redun-

dant. Chromogenic films, of which Ilford's XP1 is the outstanding example, can now produce grain so fine that it is hardly visible even when enlarged to several times the size of a normal print—so much so that one photographic magazine has already hailed the film as 'the poor man's zoom lens'.

The really astonishing thing about XP1 is not that it is fine-grained, but that it is fast as well, with a speed of 400 ASA. ASA stands for American Standards Association, the most popular of the several scales used to relate the speed of one film to another. On the ASA system the relative speed of a film is directly in proportion to its rating: a 400 ASA film is twice as sensitive as a 200 ASA film, and so on. Films are generally considered slow if their ASA rating is below 50, medium-fast if it is between 50 and 200, and fast at anything above that—usually up to 400 ASA, although it can be higher.

The speed of a film is as important a part of the exposure equation as either the shutter speed or the aperture setting. To return to the bucket-and-tap metaphor, if the aperture represents the rate of flow of water into the bucket and the shutter speed is the length of time the bucket is held under the tap, film speed is

Left Kodachrome captures the colours of an Aberdeen fishing boat. **Top** Ektachrome gives slightly less sharp results but higher speed for a shot of the doorman of the Mandarin Hotel, Hong Kong. **Above** A French château, also on Ektachrome, in 2¼ format.

represented by the size of the bucket. A large, slow-filling bucket (say, a film with an ASA rating of 25) requires more water than a small, fast-filling bucket (400 ASA). Any miscalculation with regard to a film's speed can therefore be disastrous and if your camera has any kind of built-in metering system you should always make a point of setting the rating on the film-speed dial as soon as you load a new film into the camera.

The big advantage of the ASA system's double-the-rating/half-the-exposure logic is that a film that is twice as fast as another will always require exactly one stop less exposure. If for some reason you want consistently to under-expose a film by one stop the easiest way to do it is by simply adjusting the film-speed dial to show an ASA rating twice that of the film you are using. Conversely, if you set the dial to show a speed half that of the proper rating, the meter system will react by over-exposing every shot by one stop.

If you develop your own films or have access to a good film lab you can introduce a degree of flexibility into the film's stated speed by 'pushing' it—leaving it longer in the developer. If the sums have been worked out correctly the film will still be properly exposed

even if you have given it a nominal rating of two or three times its stated speed, although the results will be noticeably grainier.

And if you ever find yourself with that one-in-a-million shot suddenly happening in front of the camera, do not stop to adjust the aperture and shutter speed—just press the button. Make a note of what the settings are and what they should have been, and work out what the film speed would need to be to produce a correctly exposed photograph. With luck you will be able to adjust the development time accordingly, ruining the rest of the film but preserving the one shot you need.

Colour film processing is considerably more complicated and push processing needs commensurate care. Unlike monochrome films, which record only the quantity of light, colour films have to record quality as well—an achievement which is made easier by the fact that what we think of as 'white' light can be split up into three primary colours—red, blue and green. (If you have dim memories of your art teacher telling you something different, remember that we are dealing with the colour of *light* here, not the colour of pigments.)

All colour films consist essentially of three separate layers of emulsion, each one of which is sensitive to one-third of the visible spectrum and responds to light in the same way as black and white emulsion. A pale blue sky registers as a dark shape on the blue-sensitive emulsion, a dark green bush as a light shape on the green-sensitive emulsion, and so forth.

Colours that consist of more than one primary colour, such as yellow, produce changes in more than one layer, in this case the green-sensitive layer and the red-sensitive layer. (More confusion: red paint plus green paint produces brown paint; red light plus green light produces yellow light.) When the film is developed the halides are transformed into black metallic silver as before, but in colour-negative film further chemical reactions are built into the emulsion to release 'dye couplers'—coloured re-agents that appear wherever the halide-to-silver conversion occurs. As this is a negative the colours produced are the opposite of those in the original subject: the green-sensitive layer has magenta-coloured dye couplers, and so on. The silver is then bleached out and the resulting negative can be used to

reconstitute positive prints that, all being well, echo the original colours.

As with Fox Talbot's first calotypes, the major advantage of colour negative films is that one negative can be used to produce thousands of identical prints—a process which is possible with colour slide film, but not so simple. It is also easier to look at a colour print than it is to look at a transparency—you do not have to hold a print up to the light or go to the trouble of viewing it through a projector. But unless you are going to be doing your own processing there are problems with the mass-market film-processing laboratories to whom you will almost certainly be sending your film. (I must declare an interest here, to maintain my journalistic integrity: I have a close connection with one of the more reputable film labs which, needless to say, suffers from none of the problems outlined here.)

Whilst you should make sure that the lab to which you send your film is not overcharging you, do remember that the cheaper they are, the more likely they are to be extremely popular. That can mean that if your film has the bad luck to go through towards the end of a batch the developing chemicals may well have already been used on hundreds of other films

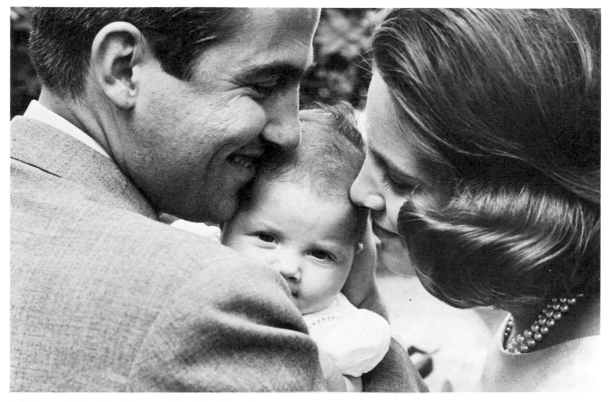

Left Ryan O'Neal in characteristically relaxed pose at his beach house at Malibu. **Above** The King and Queen of Greece with their first child, pictured in Athens shortly before they went into exile.

and your prints will tend to be muddy. I am also told, incredible as it sounds, that some labs deliberately alter the colour balance of their printing machines, so that the holiday snaps that form their main stock-in-trade always make the people in them look just that little bit more gratifyingly suntanned—a great idea if all you have photographed is people on beaches; a truly awful idea if you have sent them your prized Alpine snowscapes.

The only professional photographers who use colour negative film are the ones who cover weddings for a living. They have to be able to produce colour prints quickly and easily to keep the relatives happy. If you are at all serious about photography I urge you to stick to colour transparency films. They are more difficult to look at, they cannot be cropped in the darkroom, and they tend to be more expensive on a pence-per-picture basis, but the quality of the pictures they produce is superior.

Paradoxically, perhaps, all the pictures in this book were taken on transparency film:

printers always prefer to originate from colour slides.

The correct name for these slide films is 'reversal film'—a name which refers to the way that colours are produced in the development stage of a process that is explained in chapter six. The most popular slide films include the cost of developing by the manufacturer in the price of the film.

There are hundreds of reversal films on the market—all of them good, some of them excellent—but for most people the words colour slide are synonymous with the Big Yellow Box itself: Kodak.

As befits a company founded by one of photography's greatest innovators, Kodak films have an unbeaten reputation for quality and brilliance. Their two biggest-selling films, Kodachrome 25 and Kodachrome 64, come complete with the little yellow mailing bags into which you pop your film before sending it off to be processed—a ritual which has come to symbolize the end of a successful holiday for millions of families all over the world. Even if you really fancy yourself as a darkroom wizard, do not even contemplate processing these films yourself—there is no point. The developing process that is peculiar to these

films is heavily protected by worldwide patents, and the only possible advantage would be that you might somehow manage to avoid the log-jam that always follows at the labs immediately after any major public holiday.

If you are very anxious to get your films back quickly you can take advantage of a little-known service operated by Kodak which, on payment of a modest surcharge will turn your films round in a couple of days.

If you are still not convinced or, more likely, you are looking for a film that is fast enough to give you real flexibility even when the sun is not shining, you may care to try the Ektachrome range from Kodak. These films are not as fine-grained as Kodachrome, especially Ektachrome 400, the fastest film in the range. Nor do they have to be sent off to Kodak for processing, so they can be pushed if necessary. But perhaps the largest single difference is their colour balance which, to my eye at least, tends to be slightly bluer than Kodachrome. All colour films tend to have slight differences in their colour balance depending on their formulation and I have heard that even Kodachrome varies from country to country, presumably reflecting national preferences. The two pictures on page 79, although taken within minutes of each other, show the differences between Kodachrome and GAF film, highlighting the noticeably warmer tones of the latter with its tendency towards the red end of the spectrum.

Of the two I think I prefer the Kodachrome

Despite the fact that I faked the looming storm clouds with a graduated filter, low light levels would still have dictated the choice of a fast film for this shot of a village cricket game.

shot, which reflects more accurately the cool light of the rainy afternoon on which the photographs were taken. (The shots were originally supposed to be taken in full sunlight. Needless to say, the English weather did what it always seems to do when I am shooting on a tight schedule—it poured down.) Because people's likes and dislikes for different colours are so subjective I am really in no position to advise you on which colour film you should use. I can only suggest that you try out as many films as you can and compare the results. If you are going to do the whole thing scientifically, do make sure that both subject and lighting have at least something in common. There is no point in comparing a dawn shot of the sea with a field of poppies at sunset.

In some films the colour balance is deliberately distorted to take account of the different colour temperatures of various artificial lighting systems. 'Daylight' films are adjusted not only for daylight but also for blue bulb and electronic flash, which have a colour temperature of 5500 on the Kelvin scale. High-powered photoflood bulbs, however, which many people use for studio lighting, have a temperature of 3400 K which produces an artificially warm colour cast unless heavily filtered or used with special 'tungsten-balanced' films.

You will probably have already noticed this effect if you have been experimenting with indoor portraits taken on high-speed films and lit only by ordinary household lamps. Domestic lighting has an even lower temperature than the weakest tungsten system and the results are heavily biased towards the red end of the spectrum—very flattering on most skin tones but also extremely inaccurate.

If you ever feel that you have exhausted the possibilities of the usual colour films, try out a few rolls of infra-red film. All ordinary films are balanced to react purely to the visible spectrum, the wavelengths between 400 and 700 nanometers. Light waves with a shorter frequency than 700 nm, which start where the red end of the visible spectrum leaves off, are normally invisible but can be captured with a camera loaded with films such as Ektachrome Infrared, which combines a red-and-green-sensitive emulsion with a layer that records infra-red light. The colours in the resulting photograph depend as much on the heat emitted by the subject as its actual perceived colour and tend to be unpredictable, to say the least. Kodak rate the film at 100 ASA when used with the recommended heavy yellow filter, but exposure is probably best determined by old-fashioned trial and error. Focusing is also tricky, owing to the different speed at which infra-red waves travel through glass; the best way to get sharp results is to focus on a point

Left A studio portrait of Lord Pembroke, glimpsed over the top of *The Sporting Life* and shot on Plus X. **Above** An Ascot official peers over the heads of the crowd, shot on Kodak Recording film.

just a few centimetres in front of the main subject, or to master the infra-red focusing scale which some cameras have.

Other films which are designed for scientific and technical use but which can be used to produce unusual results include lith film, which is extremely contrasty and tends to reproduce everything in pure blacks and whites, and Kodak Recording film, an extremely fast (1000 ASA or higher) but extremely grainy film originally designed for surveillance work.

Another odd-man-out is Agfa's Dia Direct, the only black and white transparency film left on the market. Properly balanced exposure requires a certain degree of care and the results are surprisingly warm for something that uses direct, rather than reflected, light. If nothing else, Dia Direct proves how conditioned we are to seeing bright, vividly coloured images thrown up on a projection screen: a few Dia Direct slides in an otherwise all-colour presentation have a shockingly bathetic effect.

When it comes to films-with-a-difference, however, there is one film that stands head and shoulders above the rest for sheer originality. In common with Kodachrome, Polaroid films include the price of development in the cost of

the film at the time of purchase; but while you have to wait a while to see the results of Kodachrome, Polaroid shots are developed before your very eyes. Spurred on, apparently, by his small daughter's disappointment at not being able to see the results of his photographs immediately, Dr Edwin Land first started working on an instant-picture system in 1943. Five years later the first Polaroid Land camera was launched on the American market.

Although the concept behind the system was relatively simple, the technology needed to produce a picture in less than a minute is extremely complex. In the earlier forms of the system, as soon as a picture had been taken, the photographer was required to pull a tab which moved the exposed negative round to the back of the camera and married it up to another sheet of paper and a pod of chemicals. Another pull on another tab removed the film package from the camera, squeezing it between two rollers and spreading the sticky developing chemicals evenly across the film. Within a minute the negative had been developed and transferred on to the absorbent top layer of the printing paper, ready to be revealed as soon as the two layers were peeled apart.

We still use film based on this kind of operation in the studio as a reference guide, using a special back on the Hassleblad. (Polaroid film cannot produce instant pictures larger than the original size of the negative, and the 35mm format would give results too small to be useful.) The film gives its best results at warm temperatures and the start of a studio portrait session is now regularly marked by the sight of one of my assistants massaging a Polaroid into life to check whether the lighting set-up is going to give us the results we want.

One disadvantage of the peel-apart system is that it is comparatively easy to mess up the picture by fingering the emulsion before it is properly dry. Various avant-garde artists have taken advantage of this, in the past, to produce manipulated prints that are half reality and half abstraction. The latest types of Polaroid film, the SX70s, frustrate such creative impulses by wrapping everything—backing sheet, negative material, receiving sheet and chemicals—into a single laminated card which is ejected from the camera automatically within one second of the exposure being com-

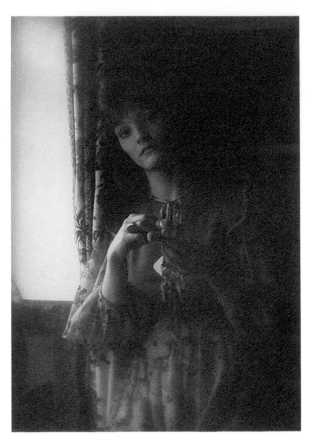

Above The speed of a film can usually be increased if it is 'pushed' during development, but quality suffers.

pleted. Each pack of film also includes its own battery to drive the ejection mechanism.

Once the rollers have smeared the developing solution across the bottom of the film it begins to spread upwards through the club-sandwich formation of the various emulsions which are interleaved with complementary layers of coloured dyes. When the developer meets silver halides that have been affected by light its upward migration is stopped in its tracks, leaving only the correctly coloured dyes to reach the surface of the film and form an image. The whole process is protected by a time-delay surface at the top of the pack which becomes clearer as the developing proceeds, literally unveiling the finished photograph while you wait.

Watching this happen is a truly exciting experience and has led me to formulate the Lichfield Law of Party Polaroids: never, under any circumstances, take more than one pack of Polaroid film to a party. The technology needed to work the small miracle that is

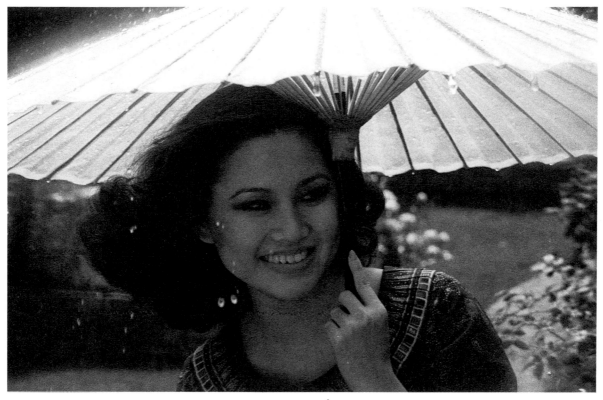

Top The reddish cast and more noticeable grain of GAF slide film (sadly, no longer made). **Above** The accurate colours and fine grain of a Kodachrome shot.

Polaroid does not come cheap and any kind of instant-picture system automatically creates a small crowd of eager subjects begging for just one more picture.

I must stress that Polaroids at parties are very much the exception to what is possibly the most important point I can make about film in general, and that it is that you should use a lot of it. During the Second World War, when film was in understandably short supply, the great French photographer Lartigue had managed to hoard just one roll of precious film from his supplies. Unable to restrain himself he went out one day intent on making the most of it. He came back with a series of pictures recording the Liberation of Paris by the Allied Army.

You, with respect, are probably not a Lartigue. Using film is the only way you can find out about photography. No amount of reading glossy books by celebrated photographers will make up for the direct experience of actually taking photographs. So, just for once, forget that film is made up from precious materials and treat it as if your name were Nelson Rockefeller. Do not buy just one niggardly roll at a time, and do not keep your camera just for special occasions: take it out and use it. It is the only way to learn.

5
THE FACTS IN BLACK AND WHITE

When the time came to photograph Lord Goodman,
one of the world's leading lawyers, my choice of film
was a foregone conclusion: a man whose working life
has been devoted to the pursuit of the plain, un-
varnished truth could only be photographed in black
and white.

Ben Jonson seems to have been the first person to coin
the phrase 'I have it here in black and white', and the
sentiment that monochrome is somehow more truthful
than colour still rings true today. Colour describes . . .
but black and white reveals.

Despite the fact that colour films that are accurate, flexible and inexpensive have been available to photographers for over forty years now, almost every single picture in any list of the world's most famous photographs would be a black and white one—a curious contradiction in a world where monochrome images are the exception rather than the rule.

The two pictures shown on this page have been included not because they are well-known enough to belong to such a list (they are not) but because I think they may help to explain the supremacy of the monochrome image in photography. They were both taken during an assignment I carried out in Israel around the time of the Six Day War and they were both deliberately shot in black and white, even though there was no practical reason why they should not be in colour.

The first picture shows the exhilaration in the face of a young Israeli soldier on her safe return from a training mission. It is, I think, fairly typical of one type of documentary photograph that has become increasingly common over the last few years, in as much as it is not so much a photograph *of* war as *about* it. This approach concentrates on the human beings involved in the conflict rather than on the blood and guts of the actual fighting—and has, to my mind, the considerable advantage of not involving the photographer in physical danger.

Pictures of war have always attracted a large audience, from the earliest examples (Fenton's coverage of the Crimean War) through to the horrifying images that came out of Vietnam in the late 'sixties and early 'seventies, particularly those of the English photographer Don McCullin. Some of McCullin's pictures would undoubtedly feature in a list of the most famous photographs, as would other well-known images of war such as Capa's 'Death of a Spanish Soldier', and Joe Rosenthal's 'Raising of the Flag at Iwo Jima'. Each one of these images and hundreds of others like them were taken for reproduction in mass-circulation newspapers and magazines, media in which economics and short deadlines dictate black and white news pictures. The net result of this onslaught of images is that, for most of us, documentary pictures are actually more real when we see them in black and white than they would be in colour—an association that I think I was at least subconsciously aware of when I chose to put black and white film in the camera before photographing the Israeli soldier. (As colour television successfully challenges the daily newspaper as the main source of our pictures of the world around us, all this will presumably start to change.)

More than a century and a half after the invention of the medium, controversy still rages as to whether photography is a valid art form, but there is surely no denying that some photographs are successful because they are attractive to the eye rather than because they convey useful information.

To any artist outside the extreme fringes of the avant-garde the idea of painting a picture using only shades of black and white would seem laughable—rather like asking a sculptor to work in two dimensions. And yet almost every well-known 'art' photograph is, once more, in black and white.

Despite the superficial resemblances between the two, painting and photography are of course very different. The creation of a painting is a considerably more labour-intensive process than the taking of a simple snapshot, and photography still has quite

Two photographs taken on assignment in Israel. **Left** An Israeli parachutist returns from a training mission. **Above** Yigael Yadin. In colour, these pictures would have taken on an inappropriate air of glamour.

some way to go before it can boast the same heritage as that of the other art-forms. But the major difference between the two lies in the relationship between each medium and the real world.

Paintings, remember, began as some kind of replacement for reality—either as some kind of mystical totem, like the cave paintings of Lascaux, or as a more or less faithful record, such as Holbein's portrait of Henry VIII.

When photography arrived, painters began to realize that the straightforward recording of reality was no longer a good enough reason for painting pictures: why bother when a camera could do it so much more efficiently? (It is only fair to point out that this was not a view held by all artists. Queen Victoria apparently asked her Court painter if he was not worried about the rising generation of portrait photographers taking away his business. 'Ah, non, Madame!' he replied, 'Photography can't flattère.')

Now that everybody knows how much easier and quicker it is to take a photograph than to paint a picture, artists who persist in recording reality with a brush rather than a lens have to face up to the whole question of the relationship between their pictures and the 'real' world. It was certainly no coincidence that the Surrealists and Cubists rose to prominence with their distorted views of reality so soon after photography became popular.

But whatever medium they work in artists, almost by definition, resist the obvious; this is why we shouldn't be surprised when artists who work with a camera choose to concentrate on the ways in which the camera can lie. On a more mundane level much the same process goes on when we look at the kind of puzzle pictures that used to feature so strongly in magazines when I was a child—blow-ups of everyday objects taken from totally unfamiliar angles. We know that this object, whatever it is, actually exists, because we are looking at a photograph of it, but at the same time we just cannot bring ourselves to believe that it is real and familiar.

For many photographers the point of taking photographs is not to record reality but to produce something that explores the way something looks—an appeal to the eye rather than to the brain. The sheer reality of a photograph gets in the way in these circumstances, because we are more concerned with what

something is than with what it looks like. When Irving Penn was first invited to produce a one-man show at the Museum of Modern Art in New York he came up with a series of fourteen still-lifes carefully printed on platinum paper, a laborious and rather antiquated process that produces very subtle and rich midtones. At first sight these pictures looked like weird tree-trunks, or old stone columns, or anything in fact other than what they really were: gigantic blow-ups of cigarette ends. Given the Museum of Modern Art's reputation as the home of all that is artistic in photography, there is a very thin line here between art and satire, but the point is that Penn had to take the pictures in black and white because coloured photographs would have given the game away too soon.

Removing the colour from a photograph takes it one step further away from reality and moves it towards being an image, emphasizing the composition rather than the content, which brings me in a rather roundabout fashion to the other Israeli picture, a portrait of Yigael Yadin, the doyen of Israeli archaeology.

My interest lay in the position he held rather than the man himself and I therefore decided to take his photograph in a particularly evocative setting rather than settle for a close-up head-and-shoulders shot. I found the location I wanted where the Dead Sea Scrolls are kept, a setting that combines a sense of history with some interesting architectural

Above left Gossip columnist Nigel Dempster prepares to puncture yet another ego. **Above right** HRH Princess Anne and her son Peter Phillips playing with Gatcombe Park's only dandelion. **Right** The Duke and Duchess of Windsor react to my falling off a chair.

forms. (The scrolls themselves are housed beneath the dome in the background.) Knowing I wanted to emphasize the compositional elements in the picture, I once again chose black and white film.

Although most of my work nowadays tends to be in colour, some of my favourite photographs have been shot in black and white, including the picture of Princess Anne and her son Peter Phillips taken on her thirtieth birthday at her home, Gatcombe Park. Whenever I am taking pictures of parents and children I try to include some kind of linking device for them both to concentrate on. In this case I decided on a dandelion, little realizing that the grounds at Gatcombe would be so well kept that the shoot would be considerably delayed whilst we all crawled round on our hands and knees looking for one.

Another favourite is the picture of the Duke and Duchess of Windsor taken at their home just outside Paris. Unsurprisingly for a couple who spent most of their lives dodging photographers, neither of them was exactly over-responsive and the Duchess in particular looked distinctly unamused as I climbed on to a valuable antique chair in pursuit of a different camera angle. I was in fact preparing to

write the whole shoot off as an unmitigated disaster when I realized that this was one occasion when I would have to be prepared to sacrifice my dignity in order to get the picture I wanted. Going into my best imitation of a hot-shot young photographer I threw myself around on the chair, shouting encouragement and slowly working my way towards the edge. As the picture shows, even they were unable to restrain themselves when I finally fell off.

Subjects like these tend not to come a photographer's way too often, and most people have to content themselves with snatched shots of celebrities at public functions. Candid shots of that sort have a long and dishonourable history that goes back to one Dr Erich Salomon, who was not above dressing up as a workman and climbing up a ladder in pursuit of the kind of photographs he later published in an album entitled *Celebrated*

Contemporaries in Unguarded Moments. If you *are* invited to the kind of function where celebrated contemporaries let their hair down, try to be unobtrusive. If everybody else is wearing a dinner-jacket then you will have to wear one too: you will not get candid pictures if everybody is looking at you in outraged horror.

A black camera body that attracts as little attention as possible helps, as does a fairly long lens (but not too long: supertelephotos can look like guns from a distance). Once you have positioned yourself, choose your moment and be decisive. Do not stop to worry about composition until you have your first picture in the bag and know there is time for another. All of the pictures shown here have been heavily cropped to emphasize the main subject and get rid of extraneous clutter—yet another reason for sticking to black and white film.

Lighting is also important. With posed portraits, such as the one of Cecil Beaton making last-minute adjustments to his exhibition at the National Portrait Gallery, you can afford to use electronic flash without worrying about its effects on the sitter (as one of Britain's leading studio-portrait photographers, Beaton was quite at home with flash). When you are

Noel Coward, Sir John Betjeman, Marlon Brando and Charlie Chaplin. Candid shots such as these require the photographer to blend into the crowd.

taking snatched shots, however, a flash gun is a sure way of drawing attention to yourself.

Salomon's ability to take successful pictures of celebrities without their realizing it was greatly enhanced by his use of the Ermanox, a camera that was remarkable at the time for the speed of its f2 lens. You should try to emulate him by taking pictures by available light whenever possible. That will almost certainly involve you in the use of one of the faster black and white films; the resulting pictures will tend to have more grain than usual, especially if you push-process the film to produce a speed rating of something like 800 ASA. That may or may not be an advantage, depending on the type of picture you are taking. Although it is not a bad rule to try to get the sharpest possible pictures you can, sometimes a lot of grain in a photograph can add to its effect.

During the 'sixties, encouraged by the growth of new magazines such as the Sunday newspapers' colour supplements, a new breed of photo-journalist began to specialize in subjects that had not hitherto been considered suitable for contemplation over the cornflakes. Although the initial motivation behind the shots of tramps and alcoholics that began to appear on Britain's breakfast-tables was undoubtedly one of social concern, it was not long before other, less talented, photographers began to jump on the bandwagon, people who knew a good trend when they saw one. (They were justifiably satirized in Antonioni's film *Blow-Up*, in which the photographer hero wearily climbs into his Rolls-Royce after spending the night taking pictures of down-and-outs in a doss-house.)

The use of flash guns in such circumstances was plainly impossible, and most of the pictures were taken on fast films that worked even in the gloomiest of settings. Fast films give grainy results and therefore almost every single 'social-conscience' photograph was remarkable first and foremost for its high level of grain. In consequence there is now a strong link between grain and social realism, even in the minds of people who do not know the first thing about photography. You can use that link to add atmosphere to your photographs, but before you do perhaps I should tell you a cautionary tale.

When a well-known children's charity approached me to ask if I would be prepared to take some pictures that they could use in their appeal posters, I accepted immediately, even though the idea filled me with certain misgivings. At the time I assumed the embarrassment I felt stemmed purely from the fact that this was not my usual kind of assignment. I did the best I could, almost automatically loading the camera with Kodak Recording film to produce the grainy shots on pages 90 and 91.

In the event, the shoot itself was not as bad as I had expected it to be. The kids had had better things to do than worry about some stranger wandering around taking pictures. So I was slightly puzzled to find that I was still not entirely happy about these pictures when the time came to dig them out for inclusion in this book. It was not the quality of the pictures that worried me: everybody assured me they were good shots and they had certainly done the job they were intended to do.

Thinking about it, what really upsets me about these pictures is their cold-bloodedness. They were deliberately designed to be touching and were deliberately shot on very grainy film to make the most of the associations that exist between grain and social commentary. They are in fact a manipulation of a tragic set of circumstances, carefully controlled to bring about a specific response. Admittedly it was all done for a deserving cause, for which the end justified the means, but they still bother me.

Taking successful pictures in black and white demands a peculiar way of looking at the world. You have to be able to see it as pure form and tone, and to ignore the effects of colour. All too often what feels like a great shot turns out to be boring because its appeal lies more in its colour than anything else. Whenever you have black and white film loaded in the camera, try to look at the pattern of things, the way the light produces shapes by the contrast between brightness and shade.

Unlike early black and white films, which reacted only to blue light and consequently made red and green subjects appear much darker, all modern films are panchromatic: that is, they respond equally well to each of the

The biter bit. Sir Cecil Beaton, one of Britain's leading portrait photographers, putting the final touches to his exhibition at the National Portrait Gallery.

different wavelengths which constitute 'white' light. Black and white films, therefore, record only the amount of light that is reflected by a subject and are not affected by the impact of individual colours. When we look at a bright splash of red paint on a blue wall, the vibrancy of the red makes it stand out in strong relief, yet the same scene photographed on black and white film could easily appear as a neutral field of overall grey, depending on the balance in brightness of the two colours.

It is possible to manipulate the way in which colours are recorded on monochrome films by using coloured filters in front of the lens. A coloured filter always lightens the appearance of anything in the picture of the same colour as itself, and always darkens any complementary colours, so to make clouds stand out more in your landscape shots use a yellow or red filter to darken the blue sky.

However, by far the most effective means of controlling the look of your photographs is to work on them in your own darkroom. I am

A children's charity asked me to take these pictures for an appeal poster. I used Kodak Recording film to add grainy realism.

Above The tiny figure of advertising whizzkid Peter Marsh dominates its surroundings by breaking up the regular composition of the empty windows.
Right Lord Lovat in the Scottish Countryside.

constantly astonished by the number of keen amateur photographers who will spend any amount of money on making sure they have the latest piece of expensive equipment yet still send their pictures away to be processed and printed. If you are even remotely serious about photography the first priority after a good camera body and lens should be a darkroom.

Almost any space you can think of will do as a darkroom provided it can be effectively sealed off against outside light. The average darkroom takes up no more floor space than a small car, and many people have produced excellent work from cupboards under the stairs. If you have a spare room that can be permanently converted into a darkroom then so much the better, but even a temporary darkroom is better than nothing.

A lot of people seem to end up doing their processing in the bathroom, presumably acting under the mistaken impression that running water is an essential part of the process. In fact there are a number of far more important things that are needed in a darkroom before you need hot and cold water on tap: the space should be easily lightproofed, adequately ventilated and, above all, supplied with sufficient electrical points (which effectively rules

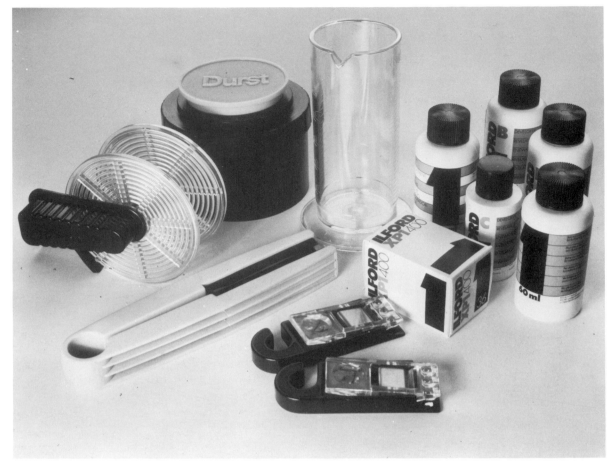

out most bathrooms because they are not supposed to have electrical points). Running water is only essential for the final washing of the completed prints, and since they are no longer sensitive to light by that stage the washing can easily be done outside the darkroom; meanwhile, they can be stored in a bucket of water.

Once you have your light-tight room, you can start to think about how to equip it; here again it is very easy to get carried away into believing that to produce truly great pictures you have to spend a great deal of money. All you really need are an enlarger (which should be as expensive as you can manage but does not have to cost hundreds of pounds), a film-developing tank, a safelight (so that you can see what you are doing without fogging your prints), some dishes for developing prints, a generous supply of photographic papers and chemicals and a few bits and pieces such as scissors, measuring jugs and storage bottles.

When you finally manage to persuade the Museum of Modern Art that your portfolio should be purchased for a substantial fee, you can begin to consider the other options, such as exposure timers, exposure meters, processing machines and so on, but for the time being try to keep your acquisitive instincts on a tight rein. The less you spend on unnecessary equipment the more you will have for the essentials, chiefly masses of photographic paper.

When I first left the Army and started to live permanently in London, the only flat I could find was, fortunately for me, directly above a photographic studio. Money was in somewhat short supply, so I was only too delighted to do a few odd jobs around the studio in return for a free run of the darkroom. It was then that I first noticed the pernicious time-warp affect that seems to occur whenever a keen photographer enters a darkroom: what seemed like half an hour and a few pictures would turn out to have been eight hours and several hundred finished prints.

The first thing you should do in a dark-room is also the easiest: sit in it for a full ten minutes to make sure that it is absolutely light-

1½-2 mins 2-10 mins 10-30 mins

Developer Fixer Wash

Home processing of black and white films requires very little expensive equipment. In addition to chemicals and a measuring jug all you need are a film processing tank, a squeegee and some clips (**left**). Print-processing requires an enlarger and three processing dishes. Once the silver halides have been transformed into black metallic silver, the print must be fixed to transform unused halides into soluble salts, then washed (**above**).

tight, meditating on the wonderful photographs you are bound to produce there. After that, on a more productive level, you will probably want to start by developing a film, turning the latent images stored in the emulsion into a set of comprehensible images. All you will need is an exposed film (preferably not an important one if this is your first attempt), a developing tank and some developer, which like everything else you use should be at the right temperature (20°C or 68°F). Unless it is really cold outside this should not be too much of a problem, but you can always warm up pieces of equipment by standing them in a warm-water bath in one of the developing trays for a few minutes.

The first part of the film-developing process is also the most difficult, chiefly because it has to be done in total darkness. To ensure an even contact with the developing fluid the film has to be threaded on to a spiral carrier before it is dropped into the light-proof tank. The first couple of times you do this it will feel as if you are trying to thread a needle with one hand behind your back and a blindfold over your eyes but, like most things in life, it gets better the more often you do it. Once the film is safely in the tank you can turn the light back on and pour in the developer, agitating the tank according to the manufacturer's instructions to keep the developer flowing over the surface of the emulsion. When the time is up, pour off

the developer and replace it with water to remove any traces of the developer still clinging to the film. Replace the water with fixer and, again, agitate to order. What is happening now is that all the silver halides in the film emulsion that were unaffected by light (and consequently not transformed into black metallic silver by the developer) are being transformed into water-soluble salts. These will be washed off when the film is subjected to its next and final stage, a prolonged washing of about thirty minutes, preferably under running water. The film can then be removed from the tank and hung up to dry in a warm, dust-free place, perhaps with a film clip attached to one end to stop it curling up as it dries.

When the film is dry you are ready to start making prints. If you can restrain your enthusiasm for a few minutes longer, it is always best to start by making a sheet of contact prints; these will provide you with a record of the images contained on the film and enable you to choose which ones you want to concentrate on when making prints. With the main lights out and the safelight on, remove a sheet of photographic paper from its box and lay it out below the enlarger lens with the negatives cut up into strips and positioned on top of it.

Like films, photographic papers come in a variety of shapes and finishes; the most important characteristic is the grade, which determines how contrasty the print will be. Paper grades vary from manufacturer to manufacturer, but the average is usually 2 or 3, with lower numbers giving less contrasty images and the higher numbers more. Perhaps the most important thing you should know about photographic paper is that in many cases it is not paper at all, but plastic. In cases where the emulsion is bonded on to paper as a support, the paper tends to soak up all the various liquids which are used on the emulsion, making it necessary to spend much longer washing the prints to get rid of the chemicals. In resin-coated papers, the use of plastic film absorbs less water and speeds the whole process up, as well as producing other desirable side-effects such as a reduced tendency to curl.

Once the negatives are laid out correctly on the sheet of paper, cover them with glass and turn the enlarger on to expose them to the light. In exactly the same way that a film is

exposed to light when the shutter opens, the silver halides in the paper react to the amount of light that reaches them through the graduated tones of the negatives; the length of time required for correct exposure will vary depending on the density of the images.

After exposure, the paper has to be subjected to the same process as the film—develop, stop, wash, fix and wash again—only this time the prints are developed in flat dishes rather than in a light-tight drum.

Still working by safelight, slide the sheet of paper into the developer, emulsion-side down, and hold it under the surface with a pair of tongs. Once you are sure it has been properly wetted, you can turn it over and watch the image develop before your eyes, gently rocking the tray all the time to keep the developer moving over the face of the print. The next stage is to wash the developer off; many people add a weak acid solution (for example diluted acetic acid) to turn this into a stop bath, which has a more immediate affect on the action of the alkaline developer. From the stop bath the contact prints go into the fixer and after about thirty seconds you can turn the main lights on to get a better idea of what the images really look like. Once the fixing is completed and the paper has been thoroughly washed, you can decide how to produce individual prints.

At its simplest, printing individual photographs is exactly the same as producing a sheet of contact prints. The sole difference is that each individual negative is held not on the baseboard but immediately below the enlarger lens, throwing an enlarged image on to the paper. The height of the lens and the focus are then adjusted to provide a sharp image of whatever size you require.

It is quite possible to approach the whole operation of printing photographs as a kind of small-scale production line once you know what you are doing, but that ignores the vast range of possibilities open to you in terms of how you can manipulate the image. The picture of designer David Mlinaric is a case in point. Since David has designed virtually every home I have ever lived in I was particularly pleased to find him on the list of designers that a magazine called *Status* asked me to photograph in the 'sixties. Since designers work primarily with their eyes and their hands, it

seemed only natural to choose a pose that concentrated on these, with harsh sidelighting to introduce a note of drama. Although I liked the result, I realized that it could be much more dramatic if drastically cropped to emphasize the main features, and that it should also be possible to highlight certain areas with a combination of dodging and burning-in.

As with film, the amount of light that reaches the photographic emulsion in a print has a direct relationship with the darkness or lightness of the final image. However, it is possible to interrupt the flow of light on to the paper whilst it is under the enlarger by masking out portions of the projected negative which you cannot do with film. A small piece of cardboard mounted on a thin wire can be used to lighten part of the image in comparison with the rest by shielding it from the light (dodging). Alternatively, a small hole can be cut in a larger sheet of cardboard to allow more light through on to a part of an image that needs to be darker (burning-in). These techniques are very useful when correcting improperly exposed negatives, but the cardboard must be kept constantly on the move.

This combination of cropping, dodging and burning-in in the Mlinaric portrait demonstrates the flexibility of working with your own darkroom and I must admit I am particularly pleased with the results in this case. Above all, I think this picture proves the point I made earlier on in the chapter—it could never have worked so well in colour.

A darkroom greatly increases the photographer's flexibility. The original picture of designer David Mlinaric (**far left**) was good, but the heavily manipulated final print (**left**) is better.

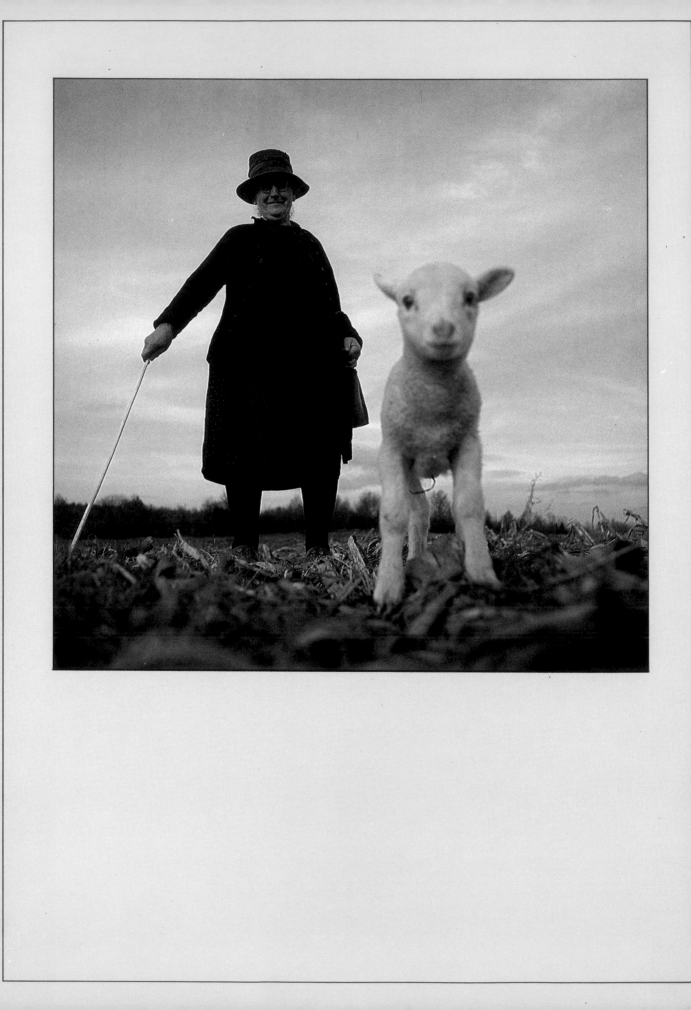

6
A COLOURFUL ACCOUNT

Although many people think of colour as the natural medium for photographs, a good colour photograph needs everything that a black and white one does and more. It needs control. The picture on the opposite page, one of my particular favourites, was taken on assignment with Osbert Lancaster and Anne Scott-James whilst travelling through France. I think part of its appeal is that it is not an overtly romantic picture, even though one might be tempted to caption it 'French shepherdess'. The important point about it is that the colours of the scene do not dominate the photograph, they support it.

Unlike black and white photography, which is always more difficult than it looks, the successful use of colour film is both more difficult and, at the same time, more easy. An ordinary black and white picture of an ordinary subject is usually just that—ordinary. And an ordinary black and white picture is quite easily ignored, passed over with no deep sense of regret.

Colour, on the other hand, offers more and demands more. All things being equal we all prefer looking at colour pictures to black and white ones and there are undoubtedly times when the sheer eye-appeal of a colour photograph is enough to lift it out of its rut, making it an attractive proposition even when the way in which colour is used has little or nothing to do with the subject of the picture. But the greater our anticipation, the greater our sense of disappointment when the initial promise is not fulfilled. A bad colour photograph will always be more dispiriting than a bad black and white.

The stakes are higher for a colour photographer because, unlike the cool and analytical qualities of the monochrome image, colours provide a strong stimulus that demands an appropriate response. It is easy to imagine that this difference in approach is entirely attributable to the greater realism of colour photography—reality, after all, is multi-coloured—but I am not so sure.

Far too often we confuse 'coloured' with 'brightly coloured', assuming that everything that is not portrayed in shades of grey must, by definition, ring with startling reds, blues and yellows. A quick flick through the advertisements in one of the Sunday colour supplements supports this view. Somebody once told me that the secret of a good advertisement was AIDA—Attention, Interest, Desire, Action—with the emphasis on AI rather than DA. Above all, an advertisement must first of all attract the eye of the potential customer if it is to succeed, and more often than not the way in which that is achieved is by the use of strong colours. (This is one reason why it costs several thousands of pounds more to advertise in colour than in black and white.) With everybody competing to use the loudest colours they can find, the results bear as much resemblance to reality as a Jackson Pollock abstract does to a Rembrandt, and the result is to devalue bright colour as a device.

Above White light can be split into at least seven separate colours: Red, Orange, Yellow, Green, Blue, Indigo, Violet or, as we were taught at school, 'Richard Of York Gave Battle In Vain'. **Right** Bright colours lend an air of excitement to this shot of Little League Baseball.

Much the same thing has happened in the world of moving pictures, where the word 'Technicolor' has mutated from being a simple trade name for a new and exciting colour process ('in living Technicolor!') to become a rather disparaging term that usually implies a certain sense of over-glamorization. I came across a telling example of this whilst watching the playback of some of the tapes we made recently in conjunction with this book.

Electronic video cameras have separate colour balance controls and when I was playing about between takes I was struck by the amazing range of effects that became possible at the twist of a knob, rather like having a set of continuously variable filters built into an SLR. Given that the sequence we were shooting was set in the Red Drawing Room at Shugborough, I was speculating on the possibilities of, say, boosting the overall opulence by adding a dash of scarlet to the video spectrum. Watching the playback I was interested to note that the lighting cameraman had shown admirable sense of self-discipline, producing the kind of subtle effects that I had always associated with film rather than tape.

When I questioned him further, he explained: 'It's always tempting to go over the top but it never looks right somehow. That kind of Technicolor jazz is all right for big-budget spectaculars but it just doesn't work on this kind of programme.'

When the use of strong colours has become virtually synonymous with unreality it is

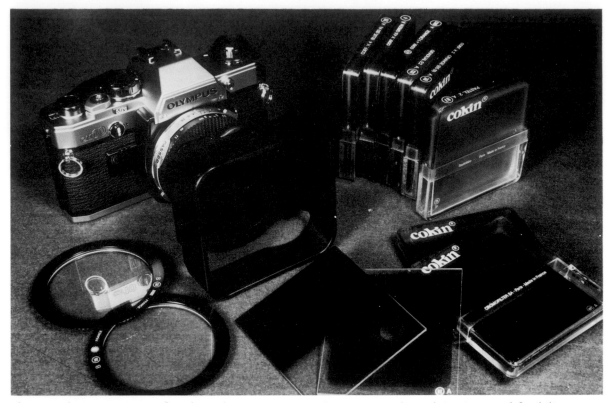

obvious that questions of reality alone are not enough to explain away the tremendous impact of a colour photograph.

The real reason why colour works so well is that it works quickly. The cones on the retina of the human eye that are responsible for detecting colour react so rapidly that we are always aware that a colour exists long before we can put a name to it. Assessing a black and white picture takes ages by comparison. If we want to know what a picture shows we have, first of all, to work out its form and compare it to the memory's library of what things look like. And before we can begin to consider a picture from any kind of aesthetic standpoint we have to allow ourselves time for the eye to move around the image, establishing the basic rhythms and shapes of the composition.

Take the picture on the previous page. Even if you have not looked at it carefully, you know it is in colour—you knew that the moment you turned over from the previous page. And in that brief millisecond's space whilst your eyes brought the image into sharp focus, it was easy to see that it consisted of a large field of one colour with a jumble of brighter colours at the top. Bright colours spell excitement and you are not too disappointed when

Filter systems (**above**) bring increased flexibility to colour photography by introducing colours and patterns not present in the original subject. Potential effects include dazzling patterns such as stars and rainbows as well as the more subtle changes produced by colour field filters, polarizers and graduated tone filters (**opposite**).

your brain finishes its analysis and concludes that this is a football game—football is something we have learnt to associate with high drama and excitement.

But in that split second whilst the page was still just a blur of colour it was equally possible that the picture would show a view of an English country garden—just as colourful but perhaps not nearly as exciting for the majority of people.

Too much colour can in fact be just as disconcerting as too little and, like most other aspects of photography, getting it right depends on the subject. From the very first moment that we first begin to use our eyes as a way of finding out about the world we begin to build up a store of pre-conceptions about what things look like. An apple is red, a banana yellow and an orange, as its name implies, orange. Individual colours have tended to become so strongly associated with special

emotions; they have passed directly into our language, and we say that somebody 'saw red', or had 'black looks'. This association carries over into special events and circumstances, and we begin to expect to see the emotional content of a scene reflected in the colours in which it is portrayed. A football match being noisy and exciting, it begs to be shown in brilliant primary colours. A picture of a couple in love, conversely, dictates a romantic choice of pastel colours and soft effects.

In general, if a photographer wants to achieve effective communication with his audience he has to make sure that he speaks the same language—a language in which shapes are nouns, patterns verbs and colours adjec-

tives and adverbs. It is always possible to get at least some kind of reaction by bucking these unwritten conventions in order to shock (a photograph of a red banana would certainly make people stop and look), but people generally prefer to spend time with people they agree with than waste it on pointless disagreement. A good colour photographer is one who knows how colour works and can use that knowledge to good effect in his work.

But colour has to be assimilated rather than learnt: our attitudes to colour, as opposed to the more technical aspects of photography, are largely emotional, therefore rational explanations often only serve to confuse matters. Even the simple observation that an apple is

red could be open to a certain amount of debate, depending on your definitions. Whenever white light strikes an object, certain wavelengths are absorbed and others reflected. In the proverbial apple the skin absorbs blue and green light, leaving the red to bounce off towards the eye. It is also possible that we perceive red as a strong positive colour not because of its traditional associations with blood and so forth, but simply because it is more difficult for the eye to focus that part of the spectrum. Similarly, we may associate blue with a feeling of distance, not because of countless views of distant hills, but because blue light is more easily focused, requiring less effort from the eye in much the same way as something does when it is a long way off.

Even the apparently straightforward idea that our emotional response to colour is the result of a lifetime's cultural conditioning is not as simple as it sounds. Whilst we in the West associate white with purity, virginity and weddings, Orientals see it as the traditional colour of funerals. Similarly, whilst we think of red as a danger signal, they see it as a happy, lucky colour.

Given the results of even a slight shift towards one colour or another in the spectrum, it is obviously important that the photographic emulsions used in colour films should be as 'neutral' as possible. Both Niépce and Daguerre seem to have been working on the possibilities of some kind of colour film before they died but the exact details remain shrouded in mystery. One possibility is that they were jointly working on some kind of single-layer process based on the manipulation of silver salts in such a way as to record something of the colour of a subject as well as the intensity of the light it reflects—a process that is apparently quite feasible but for the problems associated with fixing the image permanently.

Early pioneers concentrated their attention on various types of three-stage processes, taking advantage of the way in which almost any colour in the spectrum can be reproduced with various combinations of just three primary colours. Once the basic information on the intensity of each type of light has been recorded on emulsion, colour can be reintroduced in one of two ways, subtractive or addi-

tive. Most of the earliest efforts were based on additive methods; this is best illustrated by James Clerk Maxwell's process, which combined three separate lantern slides in careful register to produce a relatively accurate photograph of a piece of tartan ribbon.

The Joly process—invented by a Dublin professor of geology, John Joly—took matters one stage further by recording all the information on a single sheet of emulsion which was exposed through a screen of finely drawn coloured lines. Once the thinly striped monochrome image had been processed it could be viewed when bound up again with the

Filters can add a spurious touch of excitement to pictures if the central subject is strong enough (**left**). Graduated filters can create instant stormy skies on an otherwise perfect day (**above**).

coloured screen, relying on the eye's inability to distinguish between small areas of colour that are close together. (The process survives as a basic principle of colour television.)

But by far the most popular of the early additive systems was Autochrome, which was developed by the same Lumière brothers who were responsible for so much of the pioneering work done in the cinema. Autochrome produced colour pictures by means of tiny dots of colour (actually compressed grains of dyed potato starch), rather than thin lines. The results, although not quite as accurate as modern emulsions, are none the less extremely attractive, with an almost Impressionist feel to them.

The real breakthrough came in 1935, thanks to a long and fruitful collaboration between Man and God. Mannes and Godowsky were two highly dedicated American amateurs, musicians by training, who spent every moment of their spare time pursuing the possibilities of a new method of colour reproduction. By 1933 'Man' and 'God', as they were known to their colleagues, had begun

work in the labs of the Eastman Kodak company and were heavily committed to a subtractive process, in which colour is produced by subtracting colour from white light until the required results appear. Although they were highly intrigued by the possibilities of dye couplers—chemicals that could be linked to the development of silver halides to produce colour directly in the photographic emulsion—they were under a great deal of pressure from the powers-that-be at Kodak, who were very much aware of the effects of the Depression on sales of photographic equipment.

With Kodak's top management demanding something new that could be relied upon to produce sales, the two men eventually succeeded in producing a process, based on only two primary colours, that would be used mainly as a replacement for the cumbersome additive-type home-movie films that were then popular. Despite the fact that their film was being pushed into production as fast as possible, Mannes and Godowsky felt that they could do better and pushed ahead with their research. Abandoning dye couplers for the time being, they began to examine instead the possibilities of introducing colour into the emulsion at the development stage, working

Polaroid test shots from just some of the shoots done during 1978, ranging from portraits of Barry Sheene and James Hunt, Joanna Lumley and her son and the Duke and Duchess of Westminster to glamour work for Unipart and a series of pictures for a television manufacturer.

all the time with the deadline of the launch of their previous film hanging over them. Given that the film they came up with was Kodachrome, to say that they succeeded is something of an understatement. The three-colour Kodachrome was accurate, inexpensive and suffered from just one disadvantage: the way in which colour had to be built in during development made the processing of the film extremely complicated, which meant it had to be returned to the factory (in much the same way as the first Kodak cameras).

A few years later came the film that Man and God had been after all the time, one that included dye couplers within the emulsion and could therefore be more easily processed at home. That film, Ektachrome, together with the original Kodachrome and a film for colour negative prints, Kodacolour, have proved so successful that they have become the standard against which all other colour films are judged, and Kodak has never looked back.

Today, of course, a well-equipped photographer can undo all those years of painstaking research in seconds, simply by reaching for one or other of the hundreds of colour filters on the market. And if it is true that colour film itself is a much more challenging medium simply by virtue of its increased power, then colour filters must surely represent the ultimate challenge. The potential that lies in just a handful of different filters is enormous, but the problems are manifold—not least, the almost irresistible temptation to create pictures which are about nothing more than the simple desire to show off. Like anybody else, when I got my first set of filters I rushed out and shot off roll after roll of outlandish pictures of which not a single one now features in my portfolio.

The most sensible, down-to-earth filters are the colour correctors, whose job is purely and simply to adjust the colour temperature of light before it enters the camera, modifying it to suit the film being used. The correct pale blue filter will cool studio tungsten lighting to match the colour balance of daylight film; an amber one will warm up daylight to produce correctly toned results on tungsten balanced film, and so on. There are also the stronger red, green and yellow filters already mentioned in conjunction with black and white film as well as with infra red: these, like the others, are all

Nanny and child in a London park. I chose a higher viewpoint for interest and a skylight filter for safety.

designed to increase the accuracy of the final image under difficult conditions.

Once you step outside these carefully prescribed limits you start to use filters as a means of altering reality, and the odds on success begin to lengthen.

Basic colour field filters come in almost every colour of the rainbow and have varying degrees of saturation; they range from pale browns that will deepen a model's suntan to dark blues that make everything look as if it

had been shot at the dead of night. Like other photographic devices, these should never be used without a great deal of thought, but they can be extremely useful in last-gasp situations when there seems to be no other way of making the picture interesting. Both of the pictures shown on page 104 are examples of this kind of shot. They are by no means the best pictures I have ever taken but I think they do work quite well, mainly because the central subject is strong enough in both cases to keep the interest focused where it belongs, on the picture rather than on the amazing colours.

Although most colour field filters are solid slabs of colour there are other versions in which the colour shades away to clear glass. My particular favourites amongst these are those that have only half the image coloured in with a graduated tone. With an appropriately coloured 'grad' filter you can darken the sky in a shot without affecting the foreground, reducing the contrast between the two. With one of the stronger grads you can introduce heavy tints into the clouds that will simulate brooding stormy skies even in sunny weather.

Overleaf A sober judge from Trinidad and a laughing lady from Jamaica, two of my favourite pictures from the many I have shot in the West Indies.

Almost every filter will reduce the amount of light entering the lens, and on non-metered cameras the exposure will have to be manually adjusted to compensate for this. Even on automatic cameras the use of a graduated filter will necessitate careful exposure, the reading being taken from the foreground rather than the artificially darkened sky. For the picture on page 105 of a ship leaving for the oil rigs from Aberdeen harbour two filters were used in combination—a blue grad and a polarizer.

Although polarizing filters appear perfectly transparent to the naked eye, they in fact contain an invisible 'gate' that bars all light except that which is travelling in the right plane. Reflected light in particular tends to travel in one plane, and by rotating the polarizing filter to the right angle it is possible to eliminate totally such elements as the annoying reflections you get when trying to photograph displays in shop windows. Polarizers will also allow a camera to see below a sheet of water, by cutting out reflected glare, and will darken areas of the sky at right angles to a line drawn between the camera and the sun.

UV and skylight filters are similar, in as much as they work by reducing certain kinds of light without introducing any extra colour. As the name implies, a UV filter cuts out ultraviolet light, thus removing the blue cast in distinct shadow areas; it also cuts through haze and generally warms the picture up.

Last but not least amongst this group are the neutral-density filters, rarely used by amateurs but a vital part of any professional's armoury. Paradoxically, ND filters do not affect the quality of light at all; they only reduce its overall quantity. Although that may seem to be the complete opposite of what photographers want, it can occasionally be

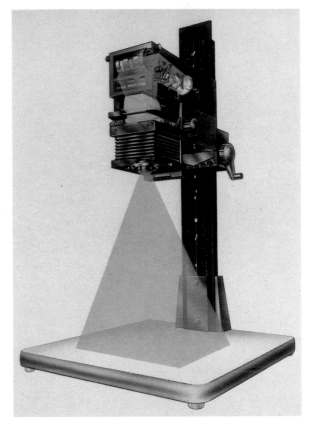

Top left Colour darkroom work requires little more in terms of equipment than black and white. **Top right** Cibachrome paper makes the preparation of colour prints from colour transparencies comparatively easy. **Above** Colour enlargers need special colour heads or packs of filters. **Right** The best alternative to processing your own colour prints is to establish a good relationship with a trustworthy colour laboratory. These are the Lichfield Labs.

useful: for example, when using Recording film rated at 3200 ASA in full sunlight whilst trying to maintain a shallow depth of field.

The last group of filters are those which a colleague of mine once referred to disparagingly as 'the disco kit'. With items such as

starburst and diffraction filters it is possible to introduce a variety of freakish effects that will streak and colour strong highlights in such a way as to make the ultimate result quite unrecognizable. Dual-colour filters and multiple-image prisms also come under this heading and I cannot say that they are my favourite photographic aids. If I want to distort the look of a photograph I usually do it not with expensive gimmicks like these but with a simple smear of Vaseline on a clear glass filter; the fuzzy edges that this produces can be manipulated to introduce a misty and romantic effect.

Provided you approach them with caution, filters can undoubtedly increase your flexibil-

ity when taking colour pictures. But they will not automatically provide you with better photographs: only experience can do that. So if you do decide to invest in some filters, do not buy the whole set in one fell swoop. Buy them one at a time, when you have some spare cash, and take the trouble to put them through their paces, noting what each one can and cannot do.

The picture on pages 108–9 was one of a series I did for British American Tobacco on the general theme of London. I am particularly happy with it because, although you would never notice, it was actually taken through a filter. Nannies and children in royal parks have

always struck me as a quintessentially British image, but the problem, as ever, was to isolate the main subject from the clutter of other activities going on. Finally I decided to climb a tree and take the picture from a higher viewpoint. The problems, and the reason I was glad to have been using a filter, came when the time arrived for me to get down. As I did so, the front of the camera caught on a six-inch nail sticking out of the tree-trunk. Luckily, in common with a lot of other photographers, I try to keep a skylight filter on the front of the lens whenever possible, not for its effect on the picture (which in nine cases out of ten is virtually negligible) but purely as a safety precaution. In this case the filter proved a very definite advantage: the filter was smashed to splinters but the lens survived unscathed.

Colour processing at home is too complex a subject to be adequately covered in a book like this, but although the processes are lengthy they are not particularly complicated. They can be carried out easily in a black and white darkroom equipped with just a few more pieces of equipment. The easiest way to start is by processing colour transparency films that do not include the price of factory development in the cost of the film, and have the advantage of requiring very little equipment. The process is much the same as for developing black and white films but includes several other stages, in one of which the remaining halides are deliberately 'fogged' (either with chemicals or by exposing them briefly to a bright light).

Producing colour prints can be done either subtractively or additively, using one exposure through three filters or three exposures through three separate filters. The subtractive method is by far the most common; it helps if you have an enlarger with a colour head that allows you to dial in different degrees of colour filtration, although it is perfectly possible to manage with a simpler and less expensive set of approximately twenty acetate filters. You will also have to invest in a special colour safelight that is dimmer than those used for monochrome work and be prepared to work with chemical solutions that need higher temperatures.

Making test prints takes longer because of the problems of dealing with three separate variables rather than one. However, once you have the right exposure, processing the prints is fairly straightforward, especially if you can afford to invest in a print-processing drum rather than use the same dishes that you would normally use for black and white pictures.

It is also possible to obtain prints directly from colour transparencies, using Ilford's Cibachrome process. Notable for the brilliance of its results, it is quite simple to use. The four-stage process—develop, bleach, fix, wash—takes only twelve minutes per print.

If you do not want to go through this hassle you can of course always take your pictures to a processing lab, but do make sure you choose one you can trust. We started the Lichfield Laboratories precisely because most amateur photographers found themselves a bit bewildered by the high falutin talk that goes on in most colour labs in which the workload is geared to the professional photographer.

As you can see from the Polaroid board shown on pages 106–7, a very large proportion of the work we do is in colour.

Although it might seem a good idea for me to conclude this chapter by throwing out a few handy hints on how to take good colour pictures, I am not going to pretend there are any foolproof ways of going about it. Successful colour photography is something you can only teach yourself by the time-honoured method of taking lots of photographs and studying them with a critical eye.

With colour film particularly, it is very easy to confuse a beautiful subject with a beautiful photograph, assuming that what looks good on the day will automatically make a great picture. This is just not so. Brilliant colour photographers such as Irving Penn and Ernst Haas do not produce the results they do simply by going around with their eyes more open than those of other people: they work at getting what they want. No matter whether you settle for taking subtly harmonizing studies of the countryside or brash, contrasty snaps of the big city, you have to know what you want, and what you have to do to get it. And to do that, you need to know about light.

Warm evening light brings out the rich colours in this shot of a solitary newspaper reader in Florida.

7
MAKING LIGHT WORK

So far in this book, our wide-ranging definition of photography has included cameras, lenses and films, all of them extremely important—indeed essential. But the one thing that photography cannot do without is light, because light is the very medium by which we see. A satisfactory photograph is one which manages to capture light accurately; a good photograph is one which actually uses light. The picture opposite is one with which, from a technical point of view, I am rather pleased. What seems at first glance to be a relatively straightforward shot actually took several hours to prepare, blanking out an unsightly background with a white sheet, arranging the models in the best position, adjusting exposure to obtain the proper balance. And all of those problems were caused by light . . .

Dr Thomas Keith, a Scottish gynaecologist, was typical of the devoted amateur photographers in Victorian Britain whose work has survived the last one hundred years. He took over 220 calotype pictures of the streets of Edinburgh's Old Town within a short period of two years before his failing health forced him to give up. One of his remarks provides a valuable insight into the way in which the early photographers went about things. 'If you were to ask me to what circumstances I attribute my success,' he said, 'I should say that I never expose my paper unless the light is first-rate.'

So much time has elapsed since the days when those first amateurs were at work that it is difficult to know whether this reflects a stubborn artistic integrity or a hard-nosed attitude to the practicalities of photography. After all, the technical limitations of the calotype process were such that it was often difficult to produce any kind of result if the light was less than first-rate. But personally I prefer to think of Dr Keith's statement as a kind of photographic manifesto—an outright refusal to settle for anything that was second-rate.

Nowadays, with ultra-fast films, wide-aperture lenses and electronic flash guns that supply light on demand, we tend to take light for granted. Although we know it is an important part of the photographic process, more often than not we treat it as just another physical force that has to be taken into account if a photograph is to be successfully exposed. But light is more than just another variable in the exposure equation, it is the very foundation of photography. That is what photography means: 'writing with light'. And one of the most valuable things any aspiring photographer can do is to put his camera away and simply go out looking at the light.

Edward Steichen, whose career spanned almost the entire history of modern photography from the early days of pictorialism through to the rigours of Post Modernism, knew a thing or two about light. He once spent several months taking a series of pictures of a single white cup and saucer on a sheet of black velvet, amassing somewhere between one and two thousand photographs illustrating every conceivable variation of natural light. Although few of us have the time, patience or sheer dogged enthusiasm to follow

Warm autumn colours in Hyde Park's Rotten Row are complemented by the diffused afternoon light.

suit, we can learn almost as much just by keeping our eyes open.

Notice the fact that it is light alone that can tell us how something appears. Notice the way a strong sidelight emphasizes form and texture, whilst direct lighting suppresses it. Notice the way that a sudden shaft of sunlight striking through the clouds can isolate an object and

make it stand out in sharp relief from its surroundings. And notice how the intensity of light changes the contrast between light and shade, increasing contrast in bright light, reducing it in the shade.

Light affects the way we perceive the colour of things as well as their shape. Although we think of bright light as always producing the deepest colours, notice the way that indirect lighting can often bring out the true colour of some surfaces, the comparative lack of reflections allowing their real nature to become apparent. And make a note of the way certain colours react to the overcast lighting of a storm cloud, appearing almost to fluoresce.

And, of course, light itself changes colour. Although we think of natural light as being white, it takes only one day's observation to show that the light at dawn is different from

Overleaf The overcast light of a rainy afternoon brings out the strong colours of these punts moored in an Oxford backwater.

that of noon, which itself is different again from that of the early evening. My daughter Rose recently came up with one of those obvious yet difficult questions that characterize the emergence of an enquiring mind when she asked me why the sky was blue. I had to tell her that I had not the faintest idea, but I made sure that I found out. Apparently the shorter blue light waves are more easily reflected by the atmosphere than the longer red ones. When the sun is directly overhead at midday it has less atmosphere to contend with and produces the deepest blue; at dawn and in the evening when the sun strikes us at an angle it has to travel further and becomes more red.

Technical answers of this sort may make it easier to answer an inquisitive child but they are no substitute for direct experience. As a longer-term project, study the way light changes through the year. (You may care to entrust the recording of this to the camera rather than relying on the fallibility of human memory.) Contrast the bleak and biting light of winter with the freshness of the spring, and the warmth of summer sunlight with the mistiness of autumn. Above all, keep looking.

Eugène Atget began his life as a sailor, switched to acting, tried his hand at painting and only began taking the extraordinarily serene photographs that were to make him famous in the latter half of his life. Advertising himself as a producer of *Documents pour Artistes* he lived in almost total poverty, existing entirely on a diet of bread, milk and a few lumps of sugar. The only camera he could afford was old-fashioned at the time he bought it and a positive antique by the time he died in 1927, crippled by the weight of the heavy equipment he carried with him everywhere. It is an almost classic story of an artist suffering for his art, but the photographs show nothing of the pain involved in their creation. There are no people in most of Atget's photographs, no animals, just startlingly intense studies of trees and statuary in the deserted parks and gardens of old Paris. They work because the one thing Atget never had to pay for was light: in Paris, the City of Light, it was everywhere and it was free. Like Steichen's pictures of a cup and saucer, Atget's landscapes are really pictures of light, which he had made a point of observing in all its different moods.

One of the most important things to learn about light is the distinction between direct and reflected light. Although we tend to think of daylight as coming directly at us, hot-foot from the sun, it is rarely so. Some of the most stunning photographs that have been produced in the last ten years have been those from the American space programme and they all have one thing in common: a very strong degree of differentiation between areas of light and shade, made all the more obvious in pictures of the spacecraft, which was partly covered in a thin film of gold leaf.

The high contrast is noticeable because in space the light really *is* direct, with nothing to interfere with its path but the odd planet or two. Down here on earth, the sun's light is invariably reflected in, around and off banks of cloud. Even on fine days, a thin layer of water vapour is usually hanging in the upper atmosphere, busily interfering with the path of the light. The number, size and character of the clouds in the sky is probably the most important single factor in determining the quality and quantity of light that reaches us, and the state of the weather is yet another factor to be borne in mind when assessing the light.

Do not underestimate the way in which light gets bounced around once it gets down to the ground, either. Almost any surface other than a sheet of black velvet will reflect light to one degree or another. A rough, whitewashed wall will throw a soft glow on to the face of anybody standing near it, whilst a red car bonnet will project a harsh red glare. When light bounces off a coloured surface, it takes on the colour of the reflecting surface, an effect that our eyes tend to compensate for automatically if we let them. The camera, however, has no such compensating mechanism, so it is as well to make sure you have really looked at the colours in the picture before you press the shutter release.

In the studio we also deal with both direct and indirect light, in this case called the main light and the fill. Careful positioning of fill lights and reflectors is probably the single most important factor that distinguishes a professional portrait from an amateur snapshot and, again, it is possible to learn a great deal about studio lighting techniques simply by studying the pictures in fashion magazines

Morning mist blurs outlines, reducing colour to a minimum and shrinking the sun to a small, pale disc.

such as *Vogue*. (Pay particular attention to the eyes: if you can see the highlights reflected there clearly, you can work out what kind of lights and reflectors were being used.)

I can still remember the days when the instructions that came with snapshot cameras sternly advised photographers that the best way to get good results was to stand with the sun behind you. This is plainly rubbish. In addition to making sure that you do maximum disservice to your subject by forcing them to squint into the camera it is also an effective way of ensuring that the results are two-dimensional and uninteresting. Possibly by way of unconscious rebellion against those early instructions, I use a lot of backlighting in my photographs, that is, a main light source situated behind the subject rather than behind the camera. Provided you ensure that there is adequate fill from the front and take care to read the exposure values from the reflected light rather than the main light, backlighting (or *contre jour*, if you will) can be an extremely effective way of producing soft and sympathetic lighting for portraits.

It can also work particularly well with other subjects, even landscapes, but do remember that for photographers as well as fighter pilots shooting into the sun can be a dangerous

occupation. If the sun itself actually features in the picture there is always the possibility that the concentrated light rays will burn a hole in the focal plane shutter, and you will almost certainly have to deal with flare as the direct light gets bounced around between the lens elements. Sometimes, of course, flare can help rather than hinder a photograph, but in most cases you will need to supplement the lens hood by asking a friend to hold some kind of shield over the top of the lens.

With strong backlighting, where the contrast between the background and the central subject is particularly pronounced, opening the aperture up by a couple of stops more than the meter indicates may not be enough, especially when you need to retain some detail in the lighter background. In such cases it helps if you have remembered to bring your flash gun with you. In contrast to situations in which flash is used as the main source of illumination, fill-in flash is intended only as a subsidiary light and it is important to make sure that the power is contained if you are not to lose the effects of the daylight. Some of the more expensive flash guns have facilities for controlling the power independently but in most cases you will have to fool the flash gun, either by doubling the

setting of the flash to camera distance or, on the automatic models, by dialling in a lower aperture.

In most cases, however, the only thing you will need to take good pictures by natural light is a good eye and a lucky rabbit's foot for the weather. I have been doing pictures for Burberry now for several years and I think I am right in saying that on every single shoot we have done so far the weather, appropriately enough for the manufacturers of the classic English raincoat, has been extremely inclement. On a recent shoot I wanted to try something different, relying on the fact that everybody knows what a Burberry looks like to set the models further away from the camera in typically English settings. Although I really did not want it to rain I was prepared for the worst to happen and had made sure we were carrying ample supplies of fast film and one umbrella per person (plus one for the camera). Needless to say, the weather was superb.

Having the right weather also helped produce the picture of my daughter Rose shown on page 126, even though it was taken indoors. With my penchant for backlighting I am particularly keen on posing people in windows, where the window frame often helps concen-

Above and facing page Figures in a landscape for Burberry: typically English light for a typically English product. **Left** The Countess of Lichfield prepares to go fishing. Cellophane from a cigarette packet blurs the edges of the picture and concentrates attention at the centre.

trate the composition. The only problem with this technique is that windows tend to produce particularly directional lighting, so that when there is bright sunlight outside there is often a very harsh contrast between the lit and unlit sides of the sitter's face. With Rose's picture there were no such problems because it was a typically grey day. For the adjacent photograph of Lord Clark, however, taken at his castle in Kent, I had to find some way of softening the light. Fill-in flash would have helped but it seemed somehow inappropriate for a man dubbed by *Private Eye* magazine 'Lord Clark of Civilization'. Given that we had decided to take the pictures in his library, the obvious answer was to let a book do the work; carefully positioned, the white pages of the open volume reflected light back from the window just where it was needed.

With the picture of Her Majesty the Queen, which was taken as part of a series celebrating her Silver Wedding anniversary,

Top Harrow station on tungsten balanced film (**left**) and daylight film (**right**). **Above** Lord Clark reflects on a book whilst the book reflects on him. **Right** My daughter Rose seems blissfully unaware that stronger sunlight would have ruined her picture. **Far right** Her Majesty the Queen takes up an informal pose with the corgis amidst her favourite Scottish countryside—another backlit picture.

the sky does not form an important part of the picture, so even though the picture is backlit, correct exposure was no problem. This type of picture is always difficult to get right, not because of any particular lighting problems, but because one has to strike exactly the right balance between the formality that befits a head of state and the informality that makes for a pleasant picture. The Queen, however, is a keen amateur photographer and the popularity of this photograph owes as much to her patience as it does to any skill of mine.

Balancing different light sources is also a problem when you are using any kind of mixture of tungsten lighting and daylight. Although our eyes tend to compensate automatically for the changes in colour temperature, assuring us that an ordinary household lamp produces the same kind of colour as sunlight, there is actually an enormous difference between the two, as you will know if you have ever looked at the exterior of a house when the outside is illuminated by the last rays of the sun and the interior by artificial light. Choosing either a daylight type or tungsten-balanced film overcomes these problems with single-source lighting, but as yet there is no film that can automatically even out the colour temperatures of mixed-source lighting, which can vary from about 2000 to 1200 Kelvins.

Deciding which type of film to use under these circumstances is largely a matter of deciding which type of lighting is the most important. If you are taking a picture indoors by high-powered tungsten lighting and there is only a little daylight showing through the windows, then obviously you will choose a tungsten-balanced film. Similarly, a shot of a house at twilight taken from the garden will look best on daylight film, where the difference between the blues of the evening light and the warmth of the inside will probably add to the effect you are aiming to achieve. Beyond that there are no easy solutions.

Another kind of light source that shows a distressing tendency to produce unexpected colour shifts is fluorescent light, which is all the more difficult to cope with because the resultant bias seems to vary depending on the age and brand of the lamp. A true professional will do everything he can to determine the colour temperature of the lights, probably using an

Above Electronic flash provides instant light on demand and ranges from simple, inexpensive flash guns up to the more powerful automatic guns which can monitor their own output. Swivelling flash heads direct the light as required. **Top left, opposite** Direct flash produces flat results and harsh shadows. **Top right, opposite** Bouncing flash off a wall or ceiling produces a softer, kinder light. **Right** The fast speed of electronic flash can be used to freeze objects in motion.

expensive colour-temperature meter, and filter accordingly. Non-professionals should use a colour-print film and trust in their ability to make corrections visually, at the printing stage.

However, the most popular form of artificial photographic lighting causes no such problems. Electronic flash, as well as the fast-disappearing blue bulb flash, is specifically designed to match the colour temperature of daylight, give or take a few degrees. Although modern electronic flash systems can cost considerably more than bulbs in terms of initial outlay, their running costs work out much cheaper and the increased convenience that they offer must mean that they will soon be a standard option even on snapshot cameras. All electronic flash guns produce light by passing a very high-powered electrical charge through a sealed glass tube filled with an inert gas. Supplying a continuous current at the high voltages required is not only impractical but also extremely dangerous, so almost all systems use a built-in capacitator that takes a few seconds to store up enough energy before firing. Professional photographers who need flash light literally at the press of a button cannot afford even the few seconds needed between cycles and therefore have to have guns that are powered either direct from the mains or from separate battery packs that are carried over the

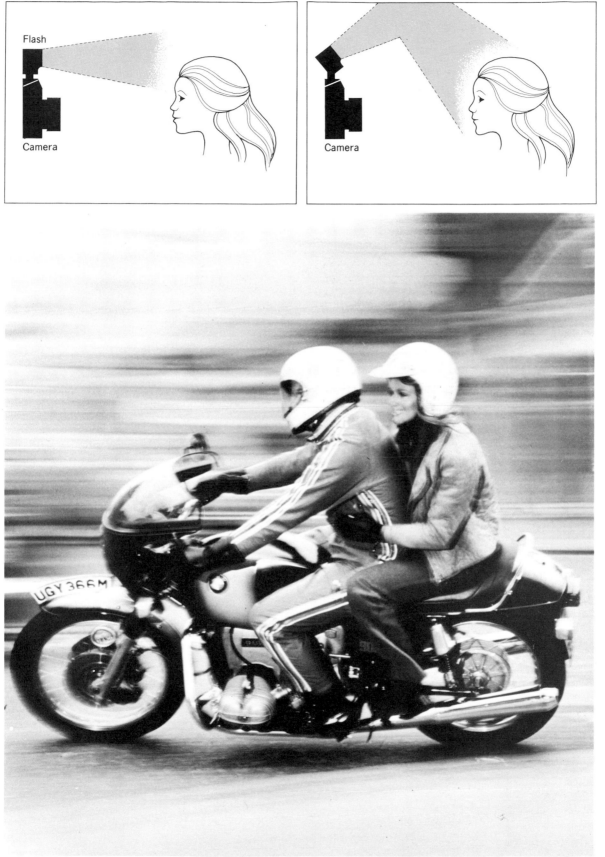

shoulder. Unless you are going to be making a speciality of studio work it is unlikely that you will need this degree of speed and in most cases the usual flash designs which include batteries within the case of the flash itself will suffice.

The most important decision that anybody contemplating buying an electronic flash has to make is whether to opt for an automatic or a non-automatic system. Non-automatic flash guns mean that you have to work out the correct exposure setting with reference to all the variables involved (film speed, flash-to-subject distance), as well as the flash gun's guide number which is directly linked to the amount of light it puts out. If the flash is close to the subject it will throw more light on it and the camera will need a small aperture if it is not to over-expose the picture. Conversely, if the flash is further away, it throws less light on to the subject and needs a longer exposure to capture as much light as possible. The whole thing is further complicated by the Inverse Square law, which says that if you halve the distance between a light source and the subject the amount of illumination will be reduced not by half but by the square of a half, i.e. a quarter. It is the Inverse Square Law that accounts for the fact that subjects close to a light source always have a much greater contrast between light and shade than when they are even slightly further off. It is also responsible for various other photographic phenomena, but it does

Above A group shot of the guests at Nicholas Soames's wedding includes his best man HRH Prince Charles with Lady Diana Spencer. **Right** A group of punks as opposed to a punk group.

not make life easier when you are trying to work out flash settings. Luckily, even the most rudimentary flash guns now have little calculator dials from which you can read off the correct aperture for a given flash to subject distance, making the process fiddly rather than complicated. If you want to keep to a particular aperture (to control the depth of field, for instance), you can of course dial that in and read off the correct flash-to-subject distance, moving the flash nearer to or farther away from the subject as required.

But whichever aperture you use, you will find that the shutter speed has to be less than $\frac{1}{30}$th-of-a-second if your camera has a focal plane shutter (and most good cameras do).

To produce an evenly illuminated picture, the whole surface of the film plane has to be evenly exposed: there is no point in having one half of the picture adequately lit whilst the other half is stuck behind the moving blind of the shutter. But most flashes give out such a brief flash of light that that is precisely what happens unless there is careful synchronization—if you are not careful the flash light will only illuminate whichever portion of the film is exposed through the moving slit between the

first and second shutter blinds. This particular problem is solved with special circuits in the camera, either through the 'hot shoe' above the viewfinder or through a separate 'X' socket near the lens. These tell the flash to fire only when the first blind has completed its traverse across the film. In most cameras the minimum time that movement takes is about 12 milliseconds (or 1/83rd-of-a-second) and if the shutter speed selected is anything faster than 1/30th the second blind will have already started its traverse by the time the first shutter blind has fully opened—automatically preventing at least part of the film from benefiting from the flash light.

Automatic flash guns, unlike others, are capable of producing an infinitely variable range of different-length flashes. Consequently the brightness of the flash can be tailored to suit the aperture required, rather than vice versa, and the choice of aperture returns to where it belongs, with the photographer rather than the flash gun. These systems are somewhat more expensive than others, but in my opinion the extra facilities they offer more than make up for that. A tiny sensor built into the front of the gun works in exactly the same way as a light meter, measuring the amount of light that is bounced back towards it whilst the flash is firing. When the amount of light measured matches up to what the meter calculates is required, the flash is turned off.

In practice, of course, these systems—like any other—can be fooled. Different colours reflect different intensities of light and very pale or very dark subjects can confuse the issue. Faced with the problem of producing a correctly exposed picture of a lump of coal, for instance, the meter will tell the flash to go on pushing out light in a vain attempt to produce the 18 per cent grey tone it has been programmed to look for (18 per cent grey is the standard tone used to calibrate metering systems). Working on an average exposure across the

whole field of view, the meter can easily be confused by large areas of distant background that will never be lit by the flash, reading them as dark subjects that need a lot of light. Similarly, the meter has no way of knowing that the large patch of light-coloured material you have inadvertently included in the foreground is not important, and will often cut the light off before it has had a chance to pass on to the main subject.

All of these problems occur but rarely and can be easily corrected on non-automatic cameras by opening or closing the aperture setting by one or two stops. In compensation for these minor difficulties most automatic systems also include a range of other facilities, such as thrysistor control (which simply means that you retain any of the charge that is left over after exposure, cutting down on recycling times) and facilities for bounce flash.

Although almost every camera has its hot shoe mounted directly above the viewfinder this is, in fact, the very worst place to keep the flash: it is the same as always having the sun immediately behind you. At its worst this positioning results in the famous red-eye effect on cheap cameras, where the light from the flash is bounced straight back off the sitter's retina, as well as making even the cosiest of family snaps look like something out of the files of the Criminal Records Office.

By pointing the flash away from the sitter and bouncing it off a convenient wall or ceiling the light is softened and diffused and (provided the reflective surface is not brightly coloured) invariably produces more flattering results. With a non-automatic flash gun you would have to recalculate the new flash-to-subject distance every time you did this, taking the increased distance into account, but with automatic flash guns, provided they allow you to keep the sensor still pointing at the subject, the calculation is done automatically and several of the more sophisticated automatic flashes have swivelling heads built in. (Some even allow you to combine bounce flash with direct lighting, which is even better.)

Portrait lighting can be done quite adequately with a flash gun, but to achieve truly striking results you need more than one light source, which is something I will be looking at in greater detail in chapter nine.

Three very different lighting set-ups for three very different people. **Top** Natural daylight outlines every single hair on the face of this farmer from Cyprus. **Above** Straightforward direct flash-lighting for a portrait of designer Valentino taken at the Savoy Hotel. **Right** High-key daylight for a picture of a young boy, shot through a glass dome.

8
ARTISAN OR ARTIST?

The original fascination of photography lay in its ability to record reality, and for many photographers that is still the prime function of the medium. My photograph of musician Clifford T. Ward was taken primarily as a piece of communication, a way of showing what he looked like.

But I flatter myself that there is more to the photograph than that. As well as being an accurate representation of the physical appearance of the man, the picture is also pleasant to look at. So does that make me an artisan or an artist? Lord Snowdon, in a recent interview, said, 'After all, we're in mechanics, not fine art. It often seems to me that taking photographs is half moving furniture and half make-up.' Personally, I am not so sure . . .

Using simple effects to create extra eye-appeal. **Above left** Mick and Bianca Jagger, just before their wedding in St Tropez, lean together to form a classic pyramid shape. **Above** Bleaching out the background concentrates attention on the figure of this extra from *Death in Venice*. **Opposite** Silhouettes strengthened by framing in a window.

One very important aspect of photography that always seems to be ignored in the glossy photography 'handbooks' that pour into the shops every year is its *purpose*. Concerned as they are with matters of how and why photography works, such books rarely have time for the larger considerations of what photography is *for*. There is nothing particularly puzzling about that, of course; the question of what distinguishes a snapshot from a work of art has preoccupied critics ever since the first news of Daguerre's invention hit the headlines, and no one person seems to have yet come up with an answer. But I do not see that it is possible to pretend that you can improve somebody's photographic ability, as the manuals often do, unless you are prepared to enter into some debate on the nature of photography itself. Therefore, bold, or foolish, as I am, I am prepared to tackle the matter.

At its simplest, photography is no more and no less than a means of recording reality, a way to store up information about people, places or events for future study and analysis. Particle physics is a case in point. In their attempts to find out how things tick, nuclear physicists spend billions of dollars winding sub-atomic particles up to something like 99 per cent of the speed of light before sending them crashing into other all-unsuspecting particles, hoping to discover evidence of yet more and undiscovered particles lurking amidst the debris. The problem is to find some way of seeing what has happened, given that few sub-atomic particles live for longer than one-millionth-of-a-second and most are far too small to be seen with the naked eye. The answer, predictably enough, is to use photography, recording the tracks that the particles leave in the bubble chamber in much the same way a jet plane leaves a trail behind it in the sky. There is no 'art' whatsoever involved in this process. The camera has been used as a recording instrument and nothing more.

On a somewhat larger scale the camera has also formed an important part of the American space programme, recording how the Earth

HRH Princess Anne, Captain Mark Phillips and their son. The repeated shapes of the heads form a strong pattern, leading the eye effortlessly from one face to the next.

The slightly tilted posture of a forest ranger is complemented by the angle of his stick, playing against the verticals and horizontals of the barn behind him.

In this shot for BMW the eye is initially held by the dark mass of the central subject before it moves on to explore the shapes in the background.

appeared to just three men and reproducing it to be seen by millions. At some time in the future, some lucky lunar beachcomber is going to stumble across the 14 Hassleblads that the astronauts left behind.

We also use photography to record more intimate moments, from weddings to christenings to a baby's first steps. The ability to freeze-frame our family history has been both a blessing and a curse to photography ever since it began. 'A collection of these pictures may be made to furnish a pictorial history of life as it is lived by the owner that will grow more valuable every day that passes,' said the very first brochure for the Kodak camera. The emotive phraseology reveals an important facet of snapshot photography. The appeal of the family album is to the heart, not the head. Every time we look at the picture of last summer's picnic, immortalized in the family album, we are instantly reminded not just of the way that day looked but of the way it felt as well. We remember how pleased we were with the weather, how puzzled we were by what was in the sandwiches, how bored we were, perhaps, by the conversation. Snapshots are records of emotions as well as appearances and every year untold suffering is caused by people

who do not realize that holiday snaps cannot communicate an emotion to somebody who was not actually there.

Holidays seem to bring out the worst in a certain type of amateur photographer—the kind of people who only see the word camera when it appears on a packing list, sandwiched between suntan lotion and anti-diarrhoea tablets. When I was on ceremonial duty with the Grenadier Guards, the arrival of summer used to be heralded not by the first flight of the swallow but by the clicking and whirring of the infamous shutter-bug. On the face of it, the hordes of tourists who descend on beauty spots and stately homes festooned like Christmas trees in a camera store seem to be defeating the whole object of going on holiday in the first place. How can travel broaden your mind if you only ever see life like the Lady of Shalott, reflected in the mirror of a reflex camera? And if all you want to do is to record the way a place appears, why not buy a picture postcard and spend the time you save actually experiencing what you have travelled perhaps thousands of miles to see?

The answer, of course, lies in the very personal nature of photography. No postcard can provide the same memories of a place, even when it exactly replicates the photograph you have in your hand. If it is *your* photograph then you must have been there. The trouble with most holiday snapshots is that they never seem to produce the emotional response intended. Looking at a picture of the Taj Mahal in the comfort of your own home may remind you of the woman who sat next to you on the tour bus cracking peanuts, or the way your wallet disappeared shortly afterwards, but will probably not tell you much about the place itself. The reason this happens is all too often because the photographer finds it a great deal easier to think about making photographs than he does to stop and examine his reactions. If the shutter starts clicking the moment it gets within a hundred yards of a national monument, how can it be possible to generate any kind of emotional response that can then become part of the picture? You cannot get feelings out of a photograph if you have not put them in.

The same is true of photo-journalism. At its simplest, of course, photo-journalism con-

Deliberate blurring of the edges concentrates attention on the model and product in this advertising shot.

sists of nothing more than being in the right place at the right time. If what is happening in front of your lens is earth-shattering enough, any personal statement you might wish to make is irrelevant. Despite the fact that it comes from a movie film, one of the few colour pictures that would have to be included in the list of the world's most famous photographs mentioned in chapter five would be that of the death of President Kennedy, used so extensively in the Warren Report. That photograph has become known all over the world, not because of the *way* it shows something, but because of *what* it shows. As Don McCullin writes in the introduction to his book *Is Anyone Taking Any Notice?*, 'Who needs great pictures when somebody's dying?'

But as McCullin certainly knows, the best photographs come from a sense of personal commitment. The fact that a photographer cares about his subject comes across in every single picture he takes, not just because he is

Still-life on a billiard table. The overhead lighting serves to emphasize the repeated forms.

there, but because he thinks about every frame he exposes. One of the most fruitful collaborations between governments and photographers came in the 1930s in the United States when the Farm Securities Administration employed photographers such as Dorothea Lange and Walker Evans to document the plight of rural farmers during the Depression, a project totally in character with the spirit of Roosevelt's New Deal policies. The photographers involved grasped with both hands the opportunities thus presented and came back with a series of pictures that were remarkable not only for what they showed but also for the way in which they showed it. With the conditions then prevailing in the Dust Bowl, it seems quite likely that anybody armed with a camera could come back with pictures that would move people, but the commitment of the FSA photographers was such that their photographs carry an emotional charge even now, fifty years after the event.

The pictures that Walker Evans went on to take after his spell with the FSA seem to show that he had spent a lot of his time thinking about one of the fundamental dichotomies in the nature of photography: the difference between what a picture looks like and what it shows. Some photographs, like those of the sub-atomic particles, are interesting entirely because of the information they contain. Others appeal to the eye rather than to the brain: for example, Man Ray's 'Rayographs'—pictures composed entirely of abstract shapes produced by the silhouettes of objects placed directly on the sheet of film before exposure. You cannot respond to the content of a Rayograph because there is none—only composition, and patterns of light and shade.

Everybody has to draw their own conclusions as to what is the best balance between content and composition; it is much the same as deciding between the abstract shapes of an ultra-wide angle Bill Brandt nude and the pin-sharp pin-ups of the *Playboy* centrefold. But wherever you draw the line, you will probably

agree that a certain sense of composition can only work to the photographer's advantage.

The question as to what, if anything, actually constitutes a sense of composition has been asked a million times and has received a million answers. Once again, I do not pretend to have the solution. But as far as I can see, composition is entirely about making life as pleasant as possible for the eye. When we look at a photograph, we do not take it all in in a single glance; we need time for the eye to move around the picture, tracing out the lines and shapes, comparing different areas, and generally making itself at home. The more easy it is for the eye to move around, the more enjoyable the picture. And the longer we can keep the eye occupied, the greater the picture's appeal.

Take two photographs, one a crowd scene (say, a street at evening), the other a simple black wall. The crowd scene consists of a jumble of faces, random and unorganized. The brick wall has been reduced to its bare essentials, a dark slab of grey against a white sky. Looking at the crowd scene, the eye is excited

The continuous line of the horizon draws attention to the one disparate element, the horse and rider.

but confused. With no hints as to what to look at first and what to look at next, the eye flits backwards and forwards, occasionally latching on to an interesting detail before wandering off somewhere else. Looking at the wall, however, is a different matter entirely: the eye sweeps in at one side of the picture, runs across the line where light and shade meet, and leaves at the other side of the frame. If the contrast is strong enough, that is all there is to it. The eye cannot go back to explore more detail because there is none. If you could some-

how combine the interest of the first picture with the strong composition of the second you might have the beginnings of a good picture. One way to do it would be by lining up all the people from the first picture against the wall from the second: the eye would still sweep along the wall, but this time it would probably come back and repeat the movement, scanning the faces of the people in the queue, stopping at

each one to assess it as part of the whole. If you could somehow get a man positioned at the front of the queue, turning away towards the back, you would be able to direct the eye back where it had come from, leaving it ready to look for something else (for example, the reason why these people are standing here so patiently). You could provide that with a giant patchwork of light bulbs mounted above the wall, spelling out something like 'The Ink Spots in Person' or even 'Peg Leg Bates'. You could contrast this thrusting shape with a fairly generous expanse of something neutral in the foreground, maybe a stretch of untouched tarmac. After that you could start to build up the interesting details. How about a 'No Parking' sign for added irony? A poster for Eddie 'Mr Cleanhead' Vinson. And a glimpse of a confectioner's shopfront. And so on.

Above Two horses' heads counterbalance each other, emphasizing similarities, pointing up differences. **Right** Satisfactory composition can rely on strong straight lines (**above**) or simple blurs of light, as in this shot of Aberdeen at night (**below**).

In the book of Walker Evans photographs I have in front of me, *First and Last*, that picture is entitled simply 'Chicago 1947'. Like other Walker Evans pictures it does not need an elaborate caption to tell us what it is supposed to be about: everything you need to enjoy the photograph is contained within the frame. The photograph is a classic example of the right balance between content and composition and it works as well as it does because it gives the eye something to look at as well as directing it to where the interest is. Although it is relatively easy for us, with the benefit of hindsight, to

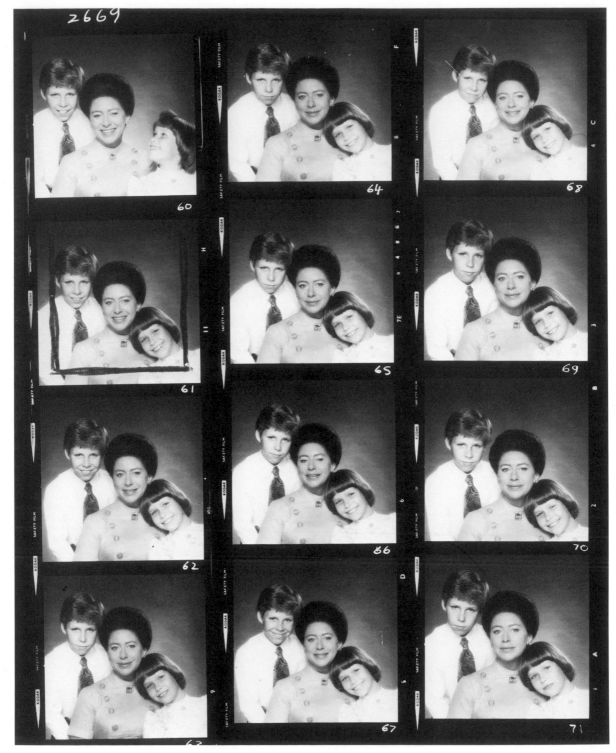

take the picture apart to see what makes it work, Evans had only a few moments in which to decide that this was what he wanted to photograph. When reactions are honed to that degree of response intellect takes second place to instinct. Or, as Walker Evans himself said: 'You know instinctively, but not why, . . . that you're on a certain track, or that you've got something . . . Get on it by luck, and follow it by instinct.'

Instinct, a good 'eye', a sense of what makes a great photograph, cannot be taught, it can only be developed. It works best when it appears to work least. With the photographs

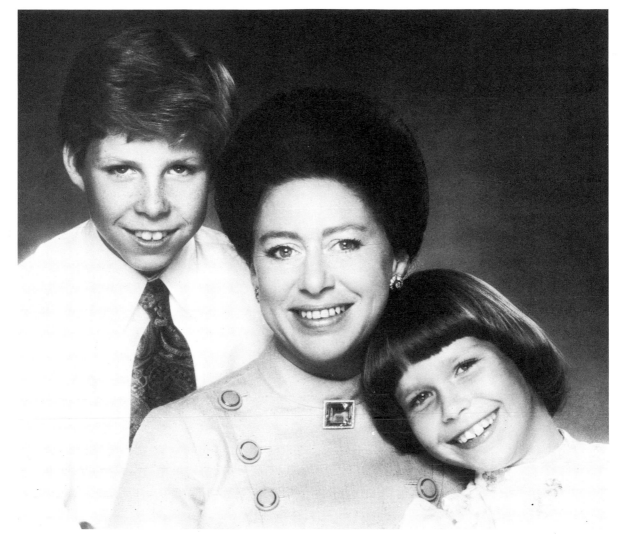

Selection is an essential part of the photographer's 'eye', not only when it comes to taking pictures but also in choosing the ones he prefers after they have all been processed. Of all the contacts of pictures taken during this session with HRH Princess Margaret (**left**), my favourite is the one shown above. Yours of course may well be different.

of Henri Cartier-Bresson, content and composition blend together so effortlessly that it can easily look like luck to the casual viewer. The fact that it is a skill can be easily proved by anybody with some time to spare, a few sheets of plain paper and one or other of Cartier-Bresson's magnificent photographs. Try to crop the image in a way that improves on the original. After about half an hour's fruitless fiddling you will begin to understand why Cartier-Bresson allows nobody to mess around with his pictures once he has shot them. It is not arrogance, but genius.

All this talk of instinct, genius and skill leads us back to the question first raised in chapter one, 'Is photography an art?'

The French courts spent months discussing that very subject during 1861 and 1862, with a view to deciding whether photographs were entitled to the same degree of protection under the copyright laws as the fine arts. The answer? 'No it isn't. Yes, it is. Is it? Yes.' (the case was subject to several appeals). Purely by virtue of its comparative youth, photography has always had to justify its artistic integrity by comparison with the fine arts, and particularly of course with painting. Whilst the infant science busied itself with reproducing reality in as many ways as possible, painting retired to a corner to lick its wounds and consider its position. For a while, most painters were quite happy to use photographs as a model in the same way as earlier artists had used the images

of the *camera obscura*. But by the time the Pre-Raphaelites held sway, photography was fast becoming a dirty word in 'artistic' circles, so much so that one of the worst comments many critics could find to make about Sir John Millais's paintings was that they looked suspiciously as if they had been done from a daguerreotype.

With no less an authority than Turner making remarks such as 'This is the end of Art. I am glad I have had my day', it is not surprising that artists began to concentrate on producing the kind of pictures that were totally beyond the camera. Indeed it is possible to see all of the great art movements of the first half of this century purely in terms of their reaction

The Decisive Moment. Photographers can never afford to 'switch off', because it is impossible to know when the opportunity of a good spontaneous shot will arise. I was very glad to have had my camera ready for this informal shot (**top left**) of Prince Charles and his cousin Lady Sarah Armstrong-Jones. **Above left** Comparing notes on our respective Army careers I was able to catch the precise moment when this Chelsea Pensioner remembered an old joke. **Above right** A split second before or a split second later, this would have been a picture of two rather lonely telephone boxes.

to photography. Impressionism employed soft-focus techniques that were totally at odds with the much-vaunted realism of the early daguerreotypes; Cubism showed one object from several different angles all at the same

time; and Surrealism went one step further by producing pictures of things seen only in dreams, where they would be quite beyond the prying eye of the camera. The process could be said to have extended right through the Modernist movement. Expressionism took the representation of reality up to supercharged levels of awareness, Abstraction is concerned not at all with real life, and Pop Art turns the whole debate on its head by taking its inspiration from the icons of modern mass communications, many of which begin with a camera.

If the result of the collision between Art and Photography was to send painters spinning off in new directions, concerning themselves more with the way in which they painted than with what they actually chose as their subjects, the effects on photography were just as important, if somewhat slower. Alfred Stieglitz, himself the husband of American artist Georgia O'Keeffe, led the Photo-Secession movement, the stated aim of which was to dignify photography as an art. Despite their good intentions, many of the photographers working with the Photo-Secession group still seemed to be concerned on Beauty rather than Truth and it was not until politics became a much more important strand of artistic life during the 'twenties and 'thirties that photographers began to invoke Realism as the be-all and end-all of photography. Typical of these were the members of 'f64'—a

group of artists who took their name from the smallest possible aperture on a large studio camera, the one that produced the most dramatically sharp results. Edward Weston was one of these men, a photographer who had originally followed a promising career as a studio portrait photographer in Hollywood, before throwing it all in to take photographs of the 'Ain't nature grand?' variety (his words, and all the more refreshing for being slightly cynical).

Although discussion between photographers as to the merits, problems and, above all, purpose of photography was limited by the comparative lack of forums for debate, it was not long before photographers began to notice what was going on in the art world, turning away from considerations of what to take photographs of, to begin working on pictures that were as much about the process of photography as they were about the results. Again Walker Evans provides us with examples, in the series of 'Subway Portraits' he produced in New York between 1938 and 1941. With the lens of his Contax pointing out between two buttons on his coat, Evans travelled the underground railway taking candid pictures of people who happened to be sitting opposite him. In conditions like these almost all of the control that we think of as necessary to a work of art was lacking; the only decision Evans could make was whether to press the concealed shutter or leave it alone. Thus described in cold print, the Subway Portraits sound like one of the more rarefied concepts that we are used to seeing discussed in the art-criticism columns of today's newspapers; the idea is so strange that if it was not for the unarguably great pictures that Evans took in other places at other times, we could be tempted to dismiss it as yet another attempt simply to come up with something different.

But Evans was undoubtedly an artist rather than an artisan, and his subway pictures were a good forty years ahead of their time. Today, artists in all media devote more and more of their time to examining concepts rather than products and contemporary art photography is often about the idea behind the photographs rather than the photographs themselves. American photographers in particular are producing some very interesting work.

Lee Friedlander, whose pictures often include a reflection of himself, is one of these, as is Duane Michals, who examines the whole question of photography's relationship with truth and time by producing short series of pictures that tell strange stories. (Titles include 'The Spirit Leaves the Body' and 'Death Comes to the Old Lady'.) The late Diane Arbus spent most of her artistic career creating dispassionate portraits of freaks and misfits, and Jerry Uelsman's photographs are carefully crafted montages that look so real you would swear they were photographs of dreams. And finally, Garry Winogrand, who says that he takes photographs to find out what something will look like when it has been photographed, is producing pictures that look remarkably like snapshots, just as Walker Evans did in 1940.

From the viewpoint of a professional photographer, some of the things that are perpetrated in the joint names of Art and Photography can occasionally seem like a sick joke— not least the activities of some collectors. These are the people, with more money than sense, who happily pay out thousands of dollars for prints that can easily be run off in limitless editions during just a few hours in the darkroom. When the market for photography starts to imitate the art market in this way, perhaps it will be time to ask if the relationship between fine art and the camera has not gone far enough. At the same time I am in no doubt that there is more to a good photograph than the simple act of pressing buttons.

What I do disagree with, vehemently at times, is the notion that all photography is art—or worse still, ought to be. As a professional photographer my job is to produce pictures on demand. People pay me for the craftsmanship I bring to a photograph but not for any theory that may or may not lie behind it. If I want to spend time meditating on the purpose of it all, that is something that I can do in my own time, not my client's.

So as far as I am concerned, the answer to the question 'Is photography an art?' is a quiet but convinced 'Yes. Sometimes'.

Jazz singer George Melly: exuberance personified and a joy to photograph.

9
PERSON TO PERSON

Never work with children or animals, they say in show-business. In the photography world, however, both children and animals can be very good news, having in common a complete lack of the sort of camera-awareness that can otherwise cause problems in portraiture.

Animals and children can also provoke a marvellous spontaneity in adults. Ava Gardner, shown here, is no stranger to the camera, but I feel that this picture, known in my studio as 'Beauty and the Beast', was particularly successful because of the dog. In fact, its appearance was entirely fortuitous. During a portrait session, the dog had begun to bark at the electronic flash, so, seeking to soothe it, Miss Gardner picked it up. When she looked up at the camera again, this was the result . . .

Photographers, like cameras, come in all sorts of shapes and sizes and each and every one of them has, or certainly should have, their own very personal views on photography. David Bailey's opinions as to what makes a good photograph are different from Terence Donovan's, and both sets of views differ from those of Don McCullin and Lord Snowdon. I know, because I have spent countless late nights listening to the four of them discussing photography. The individuality of their views is what makes them successful. If they produced carbon copies of each other's work there would be no point in their going on. This book presents my own opinions on photography which are, in turn, possibly very different from your own. None the less it would seem reasonable for me to take the opportunity of talking about myself as a photographer.

Although I owned a succession of cameras as a child I never took them particularly seriously, restricting myself, like thousands of other amateurs, to snapshots of my family and schoolfriends. My parents felt that when I left school I should try to gain some kind of experience in management, chiefly so that I would be better fitted to the job of running our estate when the time came for me to inherit it. Although I had other ideas, I meekly agreed to begin training as a young executive with a large hotel chain, a career that ended abruptly a week later when I was discovered taking pictures of the hotel manager's daughter when I should have been slaving over the books.

A period in the Grenadier Guards followed and I began to take photography rather more seriously, encouraged by the fact that as the only soldier who knew one end of a lens from the other I was much in demand as a kind of unpaid regimental cameraman. When I left the Army in 1962, what had been a hobby was beginning to be an obsession and, despite a considerable degree of opposition from my family, I got myself a job as an assistant to an advertising photographer. (This was well before photography had acquired its image as one of the more glamorous careers, and I can understand my family's feelings a little better in restrospect than I did at the time. In those days photography was still seen at worst as being seedy and at best as rather dubiously 'artistic'.) I stayed in that job for three years, underpaid and overworked like every other photographer's assistant, until in a moment of impulsiveness I left to set up on my own.

For a time it looked as if the only people who were going to flock to my doors would be debt collectors. Then I was lucky enough to land a contract with American *Vogue*. The editor of the time was the legendary Diana Vreeland, a woman of notoriously strong opinions, and when I arrived in Paris for my interview she began by asking me whom I considered the world's best-dressed man. Now I had read somewhere that self-confidence is an interviewee's best asset, so I arrogantly answered 'Me'. She did not seem too convinced so, hoping that honesty would get me further than arrogance, I changed my answer to the Duke of Windsor.

'Right,' she said, 'I want ten 10 × 8s here in my hotel by six o'clock tomorrow evening.'

Actually finding the Duke of Windsor took me the best part of the day, and when I had finally tracked him down he proved as difficult as ever to photograph. Finally I took some shots of him tying his tie in the traditional Windsor knot, carefully framing him so that his face could not be seen, and identifying him only by the Prince of Wales feathers on his signet ring.

Fortunately Mrs Vreeland liked what she saw and I was lucky enough to have the solid backing of a *Vogue* contract throughout most of the 'sixties, a time when photography was rapidly establishing itself as the best kind of fun you can have with your clothes on (or, indeed, off, depending on the kind of pictures you specialized in). In that period I was also privileged to work for a number of other prestigious magazines, including *Esquire*, *Look* and *Life*, and by the end of the 'sixties I had received a firm grounding in editorial photography.

In more recent years I have tended to concentrate on advertising work, basically because it provides a substantial subsidy for my other work. If I am to spend as much of my

Opposite, top left to right Four ways not to light a face: lighting from below looks dramatic but emphasizes facial lines, toplighting and sidelighting tend to lose detail: direct lighting results in flat results with no modelling. **Main picture** Placing the light source at a 45-degree angle invariably works best.

Above Omar Sharif, middle-aged heart-throb and bridge fanatic. Pick a card . . . **Right** Four Diana Riggs for the price of one: shots from a session for *Radio Times* showing the versatility of this remarkable actress.

time as possible behind the camera I need other people around me to look after the business of booking models, hiring equipment, organizing timetables and so on, and I am ably assisted by a secretary (Felicity), driver (Percy) and two assistants, Chalky and Pedro. The advertising commissions ensure their salaries get paid.

Commercial work can often be extremely challenging and I am grateful for any work I get, but if I had a totally free hand I think I would like to redress the balance back towards editorial work, not because it happens to carry my name, but because it gives me greater freedom to pursue my own idiosyncracies.

One theme that has run constantly through my work has been people, so much so that I

suspect that many people regard me as a specialist in portraiture. I hope that is not the case, because I firmly believe that no photographer should specialize in only one area, but if I do have to be typecast I am quite happy for it to be as a photographer of people. After all, it is a branch of photography that has produced some of the medium's most striking work as well as producing some of the best photographers: Julia Margaret Cameron, Jacques-Henri Lartigue, Karsh of Ottowa, Cecil

Beaton, David Bailey, Richard Avedon and Lord Snowdon have all made their mark primarily through their pictures of people, as have other, less mainstream, photographers such as August Sander and Frederick Holland Day. Sander, just before the Second World War, set himself the mammoth task of compiling an exhaustive catalogue of the German people in pictures—an enterprise that came to a sudden halt when the Third Reich decided they did not like the way Jews were being included in the photographic census. Day, on the other hand, produced a distinctly different set of pictures when, after a year's strenuous dieting, he posed himself as the central subject in a series based on the last seven days of Christ. Each of these photographers approached the medium in a totally individual manner but all of them chose to concentrate on the human figure, a preoccupation they have shared with countless thousands of photographers from the early daguerreotype portraitists through to today's paparazzi.

Immortalizing our fellow human beings has always been the most popular aspect of photography because we have an almost insatiable curiosity about how other people live, how they dress, where they live and above all what they are like. This curiosity is inevitably at its highest when the people concerned are celebrities, but that does not prevent pictures of family and friends being just as satisfying.

As Nadar, one of the most successful of the early portrait photographers, said, 'The person I do best is the person I know best'.

Family pictures also have a distinct advantage in that your loved ones are always prepared to give you the benefit of the doubt; they do not have to be impressed by your expensively equipped studio before they will place themselves in your hands. Some of the best portraits I have seen have been taken by available light on inexpensive equipment, relying for their effect purely on the photographer's intuitive sense of when to press the shutter release.

All too often pictures of people we already know deteriorate into simple snapshots precisely because we are relaxed in their company, forgetting that a good photograph always requires at least a moment's thought before the shutter is released. A good discipline when taking shots of this sort is to tell yourself that this picture is the one you are finally going to send off to those far-off relations you have not seen for years. Knowing that the picture you take will be sitting on somebody's mantelpiece thousands of miles away has a surprisingly salutary effect. It concentrates the mind wonderfully. If you press the button at precisely the same moment as the doorbell rings, you will produce a portrait of somebody who always looks a little distracted. If you manage to capture a fleeting moment of indigestion, the subject will always appear bad-tempered. And if you trap a genuine smile, he or she will always seem to be the nicest person in the world.

Clothes and props also assume a larger-than-life importance. (Show a happily married mother of five with a wine bottle in her hand and she will be branded for life as an inveterate alcoholic; picture a normally pin-striped businessman in his gardening clothes and he will be transformed into a down-and-out.)

To shoot Omar Sharif for a project on middle-aged heart-throbs, I used a simple prop taken from the actor's other great love—the game of bridge. Careful calculation of the depth of field (and if you look carefully you will see that his ears are out of focus) has concentrated the attention on his eyes and on the card he holds. Similarly with Diana Rigg, the contrasting pictures of whom depend for their effect on the skill of a great actress and

four costume changes: the shots were taken to publicize a series of plays for the BBC.

Although you do not need an elaborate studio to produce family pictures, it does help if you are prepared to take the plunge and actually ask somebody to pose for you. It also makes life considerably easier for your subject, who no longer has to pretend that he has not noticed you prowling around shooting off shots like a sniper. Most people start off with

The Aga Khan sits on a Sardinian hillside, his estate spread out behind him.

head-and-shoulders shots, and most people are disappointed by the results, which have a distressing tendency to look like something out of a passport-photo machine. There is no rule that says a head-and-shoulders shot has to be taken with the sitter placed head-on to the camera. Try asking him to sit at an angle, turning his head round to look into the lens.

You should also ensure that the background is not too obtrusive. At best you can pose somebody against a plain brick wall or a pair of curtains, but if the background is interesting do not be afraid to use it. Often a more distant shot of a full-length figure actually doing something, like feeding the ducks or staring at a picture, can be more effective than a head-and-shoulders shot. Another possibility

is to alter the usual angle of view—say, by taking somebody's picture as they look up at you in a first-floor window, or vice versa.

A lens that is slightly longer than usual often helps at times like these and will also allow you to take interesting candid shots of people you have never met: elderly men or women feeding pigeons from a park bench seem to be a favourite. If you are trying to take somebody's picture without them realizing it you have two options open to you: either to try to be invisible or, paradoxically, to become so visible that you disappear into the background. The first approach requires a great deal of sneaking around hiding behind bushes and buildings, and it is not one that I like

Above Singer Debbie Harry. Strong lighting and a certain amount of over-exposure combine to produce a startling high-key effect with vivid colour. **Right** The lights in my studio ready and waiting for a portrait session. The large 'Hazylights' provide the main source of light, supplemented by various smaller lamps and controlled by painted flats and reflectors.

much. It seems fundamentally dishonest, as does the use of those tricky little mirror lenses that allow you to take pictures at right angles to where you are actually pointing the lens.

A better and easier option is to hang around taking pictures (or pretending to take pictures) until your chosen subject gets used to you and begins to forget that you are there. The one thing you should not forget is your

manners. I had a period when I used to get up early to take pictures in and around London's street markets and the number of people who objected to having their photograph taken used to amaze me. If you do happen to catch somebody's eye whilst you are covertly taking their picture, have the grace to smile and say you hope they do not mind. If they obviously do, then apologize and get out fast.

Candid shots of the public at large depend entirely on a photographer's sense of timing—the instinctive ability to watch and wait for Cartier-Bresson's famous 'Decisive Moment'. Almost everything you see in a situation like this can change and it is up to you to select the split second when they all come together. You can make life easier for yourself by studying the scene carefully and distinguishing between those elements that are important (the lighting, the positioning of the main subjects, the expressions on people's faces) and those that are not, or are not going to change. If the odds are in your favour, hang on. If not, move on to something else before you lose the light.

The odds on getting a good picture always seem to lengthen when somebody becomes aware of you taking their photograph, even when they are quite happy about it. The problems are not made any easier when a photographer insists on trying to get a smile out of somebody who really does not feel like smiling. A sincere smile involves the eyes as well as

the mouth and no amount of saying 'Cheese' can make a basically sombre person cheerful. If your subject does not smile a lot there is not really much you can (or indeed ought to) do about it.

Richard Avedon wrote in his introduction to a catalogue produced for one of his exhibitions: 'I often feel that people come to me to be photographed as they would go to a doctor or a fortune-teller—to find out how they are.' That is probably a little closer to the way most of us feel in front of the camera. It is not an easy thing to cope with and it helps if you can give your subject something to do to help him take his mind off the whole process, preferably something he is familiar with. That is why it is often a good idea to take your camera to the subject rather than expecting him to come to you: your chances of finding something he enjoys doing which will also help the atmosphere of a shot are thus immediately increased. The picture of Henry Cooper on page 171 was totally unposed and I would never have got the same effect in the studio. Shooting by available light in the gym above the Thomas à Becket pub where he was training provided the perfect opportunity to get a picture that stressed the demands of his career as a boxer without actually showing him in the ring.

However, although daylight is always infinitely preferable to electric light for quality, it does tend to be restricting, and if you have a willing model it is well worth taking the trouble to set somewhere aside as a small studio. The first thing you will need is a decent lighting system which, at its simplest, need consist of nothing more than a couple of ordinary domestic light bulbs lashed up on some kind of homemade stand. The light provided by these bulbs is much weaker than daylight, so you will probably have to use a very fast film if you want any kind of flexibility, and the colour temperature produced will be low enough to restrict you to black and white film, where the colour bias will not show.

Tungsten-balanced colour films are balanced for 'photoflood' bulbs—ordinary light bulbs that are overrun to produce a much brighter light for a much shorter period. Again, it is perfectly possible to fix these bulbs on to some kind of homemade stand if you have the basic carpentry and electrical skills, but you will need to be careful. Photoflood bulbs give out a great deal of heat—more than enough to melt an ordinary plastic shade—and you would be much better off with some of the inexpensive purpose-built stands that are available. Tungsten lighting can also be bought in a variety of complete units which include their own reflectors to produce a variety of effects. The most useful of these is the 'brolly', a plain white or silvered umbrella into which the light is shone to produce a larger area of softer light. Bigger quartz iodine and tungsten halogen lamps can also produce stronger, harsher effects as required. All tungsten systems, however, suffer from excessive heat, which can be a real problem when you are doing your best to make a model feel as relaxed as possible. If you are trying to produce beautiful pictures of ice cream or long, cool, iced drinks it can be disastrous.

That is why most professional studios use some form of electronic flash, something that is quite easily replicated at home once you have your basic flash gun. You can usually produce quite a good range of different effects with just one gun and a number of carefully placed reflectors, but it is much easier if you can afford to buy one or two extra guns. These do not need to be particularly sophisticated but it does help if they can be set to control the amount of light they produce. With fixed-output guns, which is what most people start off with, you can still vary the effect by moving the guns nearer or further away from the sitter and you can avoid the usual spaghetti tangles of wiring by using slave units (subsidiary flash which is fired by the light of the main gun itself rather than being connected to the camera). Once you have these guns set up, together with your required range of diffusers, umbrellas and other reflectors, it starts to become difficult to predict the results. Even when you fire off some test flashes, the light disappears so quickly that it is hard to know what you are doing. If you have a Polaroid camera you can always record the results with that, but it does start to become expensive if you are not too sure what you are looking for. By far the best

Right This moody silhouette of model Nicky Shulman shows that pictures do not have to be crammed with detail to be effective.

option is a lighting system that includes its own modelling lights which remain constantly lit to mimic the effects of the flash, but this will necessitate a considerable financial outlay.

The only other thing you will need, besides the basic equipment, is studio space. If you can manage to set one room aside as a permanent studio then so much the better, but any area will do if you think about it carefully enough. The most important point is to make sure you have as much space as possible to give both you and your subjects room to move around.

Misconceptions about studios seem to be almost as bad as those about darkrooms and the most common myth is that a studio space has to be painted white. If you are working

Above Designer David Hicks in his London office. Shooting close emphasizes the *trompe-l'oeil* effect of the mural behind him. **Opposite** In contrast to the earlier picture of Dean Martin with *his* favourite possession, this New Guinea tribesman brought his pig to be photographed.

entirely by daylight, of course, you will want to conserve as much light as possible and white walls will certainly help. But with any kind of artificial lighting system you should be far more concerned with simply providing a suitable background for the photographs. One white wall can be useful but if you are making temporary use of your living room I do not suppose you will want to redecorate simply for a few photographs. It is much easier to hang

some kind of material in place with a few clothes-pegs and bits of string—making sure that they do not feature in the finished photographs, of course. If you need a really spotless and seam-free backdrop, you can buy rolls of coloured background paper (they are somewhat cumbersome), but it is often just as effective and a great deal easier to use whatever materials you have about the house. Loudly patterned floral prints might be too distracting, but something like an old velvet curtain or a sheet of tarpaulin can be pressed into service if it fits the kind of shots you are trying to take. (Lord Snowdon sometimes uses an old felluca sail that he brought back from Egypt.)

My studio in West London has to include a lot of other facilities besides the basic picture-taking area. It is a small house on three floors and everything has tended to be squeezed in wherever we could find room. On the ground floor there is a tiny loo, a darkroom and a miniscule kitchen used almost entirely for making black coffee. My secretary works in a converted passage surrounded by telephones and her typewriter, with her dog Jo-Jo as often as not enjoying a free run of the back patio— which is all of ten feet square. On the top floor there is another loo plus bathroom and a small dressing-room. I lived there for twelve years before we turned it over to the use of make-up artists and hairdressers preparing models before a shoot. There is also a rather rickety

ladder that gives access to the flat roof outside, furnished with a rather desultory collection of what few plants we can persuade to grow in the London air and sometimes, but not often, used for taking photographs outdoors. Most of the activity goes on in the middle of the building, where I have a small office, and, leading off it, the studio itself, which occupies about 400 square feet.

Most of the walls (deliberately painted black) are hung with a motley collection of equipment, props, camera bags, cartons of film and the vitally important do-it-yourself kit we so often need for making running repairs. There is a small skylight in the ceiling but when we are using daylight it is usually that which comes from the huge north-facing window that takes up most of the far wall. It was north light that produced the soft and subtle tones in most of the early portrait photographs, and a lot of time and effort has gone into devising artificial lighting systems that duplicate the effect as closely as possible. We use Hazylights, the large suspended boxes you can see in the photograph on page 161. As with a brolly, the overall effect is softened by reflecting the light back on itself, but here the flash bulb faces forward and is reflected twice—one from the metallic reflector at the front and once more from the large white back-surfaces of the box itself. The light is then thrown out through a layer of translucent plastic to give a soft subtle expanse of white light that produces the characteristic square catchlights in a model's eyes.

We also have a selection of smaller, more specialized lights that can be used to produce a wide range of different effects—most of them particularly useful for fashion and glamour shots. When we want to alter the overall balance of the light, we achieve it by wheeling in one or more of the large free-standing flats on the right of the picture, which are painted black on one side and white on the other. We also make frequent use of the large sheet of polystyrene shown on the left to bounce light up into a face.

The amount of film we get through in an average week would probably keep most amateurs going for a couple of months, so we always buy in bulk, usually around three to five hundred rolls at a time. Although I would really prefer to use Kodachrome, it does

Above Lighting hair correctly is as important for children as it is for fashion models. **Opposite** Eric Morecambe and Ernie Wise in comparatively sober mood.

not give me enough speed for the kind of flexibility I require and so we tend to concentrate on professional Ektachrome, rated at 64 ASA or higher if necessary. The colour temperatures of all films vary slightly from batch to batch, so we carefully check the first few feet of every bulk buy to see if it needs adjusting, by means of one of the wide range of colour-correcting filters we keep for the purpose.

The majority of the people who come to me for photographs are professionals of one kind or another, and they do not have time to waste while I check things or carry out creative experiments with the lighting. Consequently, every shoot is carefully planned to keep chaos to a minimum and allow me as much time as possible behind the camera. There is nearly always a brief meeting with the client a week or two before the shoot to allow me to see what I am up against and make sure of precisely what is wanted, and my assistants and I spend as much time as possible during the period before the shoot planning it out.

Most of the lighting is set up the night before, and once I have the main light where I want it the next thing we do is position the flats

in such a way as to complement the primary light source. As a general rule I like to position a black flat to one side of a male sitter, so that it absorbs rather than reflects the light, producing a more dramatic effect that suits the generally gaunter features of most men. With women, the flat is usually turned white-side-round to reflect light back on to the shadowed side of the face but we quite often take it back and behind to give a high-key effect. We also tend to use the toplight more with women

David Bailey arrived to have his picture taken looking very rough indeed. We decided not to fight the inevitable and instead exaggerated the effect.

because its main purpose is to produce a nice shine on the hair. Brunettes can cope with a brighter toplight than blondes and we always do without a toplight altogether when photographing anyone who is at all thin on top—I have enough to worry about without introducing needless glare.

If we want more light on the hair we can also use a kicker pointing up into one of the white-painted corners of the studio, from which point it will throw out a firm downlight that makes the side of the hair shine.

The white polystyrene sheet is nearly always positioned at an angle below the sitter's face, throwing some light back up to reduce the emphasis on any wrinkles. These lines add a lot of character, but older women tend to prefer looking beautiful to looking interesting

Although most people prefer to see themselves looking happy, a good portrait does not always have to show a smile, as this shot of Hugh Millais demonstrates.

so we sometimes also add a small kicker to alleviate the problem.

That leaves just the backlight, and with my penchant for backlighting that tends to be the one I spend a lot of time on. If the light is pushed in really close to whatever we are using as a backcloth, it spills gently out from behind

the head, giving just enough rimlighting on the hair to lift the whole face up and away from the background. If it is pulled further out, it produces a distinctive halo effect that needs a bit more care if it is not to drown out the detail in the face.

Making sure these different light sources are properly balanced takes quite a bit of time, and all of them tend to add to the amount of light that is reflected back towards the camera. To make sure of the correct exposure I always use a flash meter, which works in much the same way as an ordinary light meter but has to be synchronized to the flash to make it work properly. With the meter positioned where the sitter's head will be and pointing back towards the camera it usually takes a couple of attempts before everything is balanced properly.

On the morning of the shoot most sitters have just enough time to say 'Good morning' before they are whisked away upstairs to be got ready. For beauty shots a hairdresser and make-up artist are always booked and for fashion there is always somebody to look after the clothes as well. For portrait shoots I make sure I do at least a little research on the person whose photograph I am taking. This is not so much to ensure that I get a revealing set of pictures as to give me something to talk about.

I always try to keep a conversation going, animating the sitter and giving me the opportunity to catch different expressions as they chase each other across the face.

Getting a good response from your subject is a bit more difficult when you are photographing groups rather than individuals and much more difficult when they are all bored silly with having their photographs taken at every possible opportunity. Taking the Silver Wedding photograph of the Royal Family shown on pages 174–5 therefore presented me with a number of problems. As it happened we had set up the 5 × 4 camera on a tripod immediately behind a television set that was in the room, and as the members of the Royal Family started to filter in and take their places they all became involved, naturally enough, in the film that was on. Luckily the BBC was showing a Marx Brothers film, good family entertainment and an extremely effective way of preventing boredom.

However, when my assistant handed me a

Above The jockey's cap recalls the profession of champion Lester Piggott. **Right** Henry Cooper quenches his thirst at the end of a training session for his fight with Mohammed Ali.

Hassleblad fitted with a 50mm lens (too narrow for the pictures I was trying to take), I realized I had problems. Knowing that time was of the essence, I instinctively left my post behind the television set and began to fire off a series of shots of parts of the group, hoping to find some way of patching it all together later. The picture shown here, my favourite from the entire shoot, is in fact a carefully made composite, patched together from three separate prints and then re-photographed.

That portrait session took twenty minutes to set up and about quarter of an hour's actual photographing and was by no means unusually quick. Many of the people who come into the studio think that they are going to be there for a couple of hours, and I am afraid a lot of them tend to be disappointed when it is all over in less than half an hour. I usually shoot somewhere between sixty and a hundred frames, from which we choose the half dozen

Above Joan Collins in her Highgate home, almost but not quite overwhelmed by the reflections from her collection of art nouveau and art deco objects. **Left** Lesley Caron and her daughter, an unusual pose that emphasizes close family ties.

we like best—the essence of the ducking and weaving that makes up the average session.

As far as I am concerned, the pleasure of talking to all the people who come in to have their pictures taken almost outweighs the business of making photographs. A lot of people who have seen the film *Blow-Up* imagine that a good portrait photographer is one who gives vent to a stream-of-consciousness babble all the time, verbally raping the model with a lot of 'Ych-baby-that's-really-great-give-me-

more-of-that-oh-that's-so-good-do-it-again-yes-yes-yes!'. A good rapport is simply not created like that. All subjects like to be reassured that the pictures are looking good, and a certain amount of direction is always in order, but to get people looking happy you have to talk *to* them, not at them. When I retire at a ripe old age to rest on my laurels and contemplate the past, it will be the people I remember: Henry Cooper talking about London, the Aga Khan talking about Sardinia, Joan Collins talking about her daughter—interesting people, all of them, and interesting conversations.

Overleaf A formal group portrait taken for the Silver Wedding of HM the Queen and Prince Philip.

10
DEVELOPING
INTERESTS

Although I am not in any way a devotee of horseflesh,
one of the most enjoyable assignments I have ever
undertaken was a series of photographs of horses, one
of them shown here and others scattered throughout
this book. The beauty of this assignment was that I had
the freedom to take pictures that pleased me as much as
they did my client. Otherwise, I have to discipline
myself to spend a proportion of my time taking pic-
tures purely for my own benefit if I am not to become
stale. And in those circumstances I find myself facing
exactly the same problem as somebody who has just
picked up a camera for the first time: what am I going
to take photographs of?

Of necessity this book has been more concerned with the concrete certainties of photography than with the more ambiguous areas of attitude and opinion. Even with today's fully automated picture-taking equipment there remains a vast body of information that has to be absorbed before a photographer can aspire to anything more than a snapshot.

But photographs are not examination papers, produced in order to be given marks out of ten for technique, and a second-rate photographer cannot be transformed into a first-rate one simply by force-feeding him with photographic data. Photography is, above all, a personal medium, a way in which photographers explore the world around them. Technique can help to make the signs and symbols of photographed reality easier to read, but it cannot replace the instinct that puts them together in the first place.

Perhaps the best piece of advice that I can give you if you are at all interested in photography is that you should learn your technique thoroughly and exhaustively, mastering the whole subject inside out—and then forget it. When the moment of decision comes, when you are faced with the opportunity of either selecting an image or leaving it be, technique should be so thoroughly assimilated that you feel rather than know that this picture will work, relying on instinct rather than intellect to guide you.

Having attempted to cover all the most important aspects of the science of photography, as well as taking a few steps into the swampland of photography-as-art, perhaps I should now address myself to the most basic question any photographer could ask: 'What kind of photographs should I take?'

For a professional photographer, of course, the problem does not arise. By definition, he must take pictures of whatever people want him to take. For an amateur (and here, as everywhere else in the book, the word is intended to be complimentary rather than patronizing), literally anything goes. Nobody can tell you what to take pictures of because only you know what interests and excites you.

But do beware of treating photography as something that has to be kept separate from the rest of your life, a set of equipment and behaviour patterns that only ever come out of

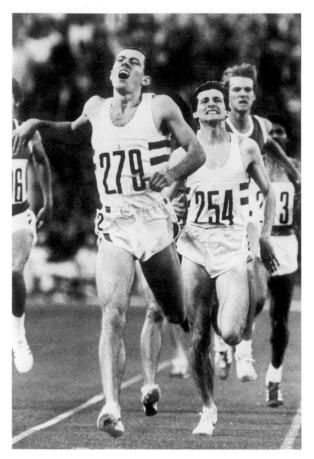

Sports photography is something even armchair athletes can enjoy. **Above** Steve Ovett and **right** Alan Wells at the Moscow Olympics.

the cupboard at weekends. If you have other interests, use photography to examine them, remembering that whilst there are lots of photographers who take pictures of other people's lives, there are also a select few who take pictures of their own.

Take a camera with you wherever you go. If you cannot fit a proper SLR into your jeans pocket, then slip in a more compact model; failing that, use your eyes to the full. When everything you do is a potential subject for a photograph the range of possibilities becomes almost infinite.

An architect can take pictures of a building to record the way in which it is built, and he can also show the way he reacts to it. A scuba diver can take a specially designed underwater camera with him beneath the waves to record what he sees there, and he can also attempt to describe what it feels like to be underwater. Even the armchair athlete can use photo-

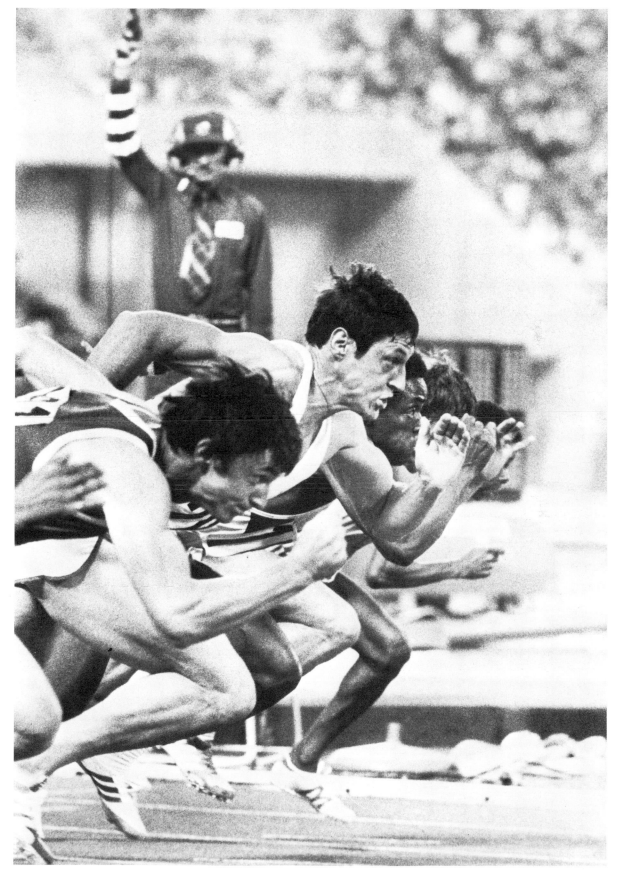

graphy to complement his other interests by taking a camera to a local athletics meeting.

Sports events, in fact, offer an enormous range of exciting picture options, as anyone who studies the back pages of the serious Sunday newspapers cannot help but appreciate. The use of expensive accessories—motor-drives that can get through five frames in a second, and long lenses that can fill those frames with action at a distance—can make life easier for a photographer, but they are no substitute for a keen interest.

If you are more of a nature-lover than a sports-enthusiast the chances are that you will soon tire of taking pictures of your prize-winning petunias. 'Macro-photography', strictly speaking, only applies to photographic techniques that produce images larger than reality but it is also loosely used as a catch-all term to cover any kind of close-up nature photography. The intricacies of lighting, lenses and, above all, obtaining sufficient depth of field could easily fill a book of their own, and if you prefer to concentrate on something a little simpler you might find it easier (and less expensive) to start with still-lifes.

Still-life photography needs little more than a spare tabletop and an eye for composition and is one of the best ways I know of training yourself in the effects of light. A useful discipline is to restrict yourself to just a few objects, experimenting with different set-ups

Above and opposite Playing in a charity match I set up my camera with the motordrive attached and got a friend to push the button as I went in to bat. Unfortunately I was out first ball.

and different types of light. On a somewhat larger scale, landscape photography represents a considerable challenge if you are to come back with anything other than predictable 'calendar' shots. Try to concentrate on the atmosphere of a landscape rather than purely on its physical aspects, and do not be afraid to go for the telling detail rather than the grand panorama. If Blake can write about seeing a 'world in a grain of sand', then you should not baulk at photographing a single tree rather than a forest. Of the two ways to hold a camera—horizontally or vertically—the former is the more common for landscape pictures (hence the name: 'landscape' format rather than 'portrait'). That seems to me to be

as good a reason as any for attempting to do the opposite, producing pictures that concentrate on the vertical elements in a view rather than the horizontals. Whatever approach you decide on, do try to think about where you are putting the horizon in relation to the frame and decide whether you are more interested in the sky or the land. There is nothing more boring than falling between the two stools and dividing the two areas neatly and equally across the centre of the picture.

Above and right Underwater photography can produce fascinating pictures, taken with a waterproof camera.

Although I have talked at some length about pictures of people, I have still done little more than scratch the surface of the subject. Children, for instance, are not always the sure-fire subjects they appear. Although all but the most precocious are usually unaware of the way a camera can trap them, capturing them naked on a bearskin rug for long enough to be shown to their fiancées twenty years later, they are also completely unaware of the need to hold still. There are two ways to approach the problem, either to do your best to keep them tethered to one spot, or to give in gracefully.

A technique I have used with success is to try taking pictures of children on the run. Calling for them to run towards you as you shoot off as many frames as you can always means their attention is more on the running than the camera, and depending on your dexterity with the focusing ring you should be able to get at least some good shots. Alternatively, you can set your camera up pre-focused on a point where you know the child is bound to be, such as climbing a stile (as in the photograph at the beginning of this book, on page 31). One firm rule that you should try to follow as often as possible when taking photographs of other people's children is to make sure that the parents are as far away as possible. If you cannot arrange that, then find something for them to do too, thus avoiding the pain of watching a desperate mother trying to coax a smile from a determinedly fractious child.

If you sit children down with a favourite toy, or better still a new one, you should be able to keep them immobilized for long enough to get some good pictures; try to arrange things so that the camera is below them, to avoid running the risk of annoying them by constantly calling for them to look at the birdie rather than the toy.

Children often enjoy looking through the viewfinder before the session starts, and if you can manage to stop them getting their sticky fingers all over the lens it is a good way to familiarize them with what is going on. Above all, do not talk down to them.

For a lot of high-street portrait photographers, if it is not a christening then it must be a wedding. If you are ever asked to take the photographs at a friend's wedding, try to steer a middle course between your own photo-journalistic instincts and the bride's mother's demands for pictures she can show to the neighbours. Uncle Ernie falling down drunk might make an unusual picture, but it is not the kind of picture most newly-weds want to remind them of the reception. Provided you take care not to inflame further the mixed emotions that are always simmering just below the surface of any matrimonial event, there is usually a host of opportunities in the build-up to the ceremony as well as at the junketing afterwards. Custom declares that a bridegroom must not see his intended before the event, but

Overleaf Nature photography needs a stealthy approach and a long lens to avoid alarming timid subjects. These shots are by bird photographer Eric Hosking.

there is nothing to prevent the photographer doing so.

Whatever other pictures you manage to take, it is certain that you will have to cope with the habitual wedding groups just outside the church. These shots are amongst the most difficult to get right because they are almost mummified in tradition. They are also the ones that have to be right: no amount of clever pictures from behind the scenes will make up for a botched group shot. So be firm if you have to, marshal people into the places where you want them, and try to be tactful when the father of the groom starts countermanding your instructions. Although it is difficult to take wedding groups that are not symmetrical, see if it is not possible to introduce a more interesting composition by breaking people up a bit, rather than forming them into two or three staggered lines like a football team.

Situations like these are not exactly calculated to allow your instincts full room for manoeuvre. You will be far too busy wondering whether the pictures will come out to worry about what they look like. So unless you are at your best in a crisis, relax. Three of my favourite pictures reproduced in this book were taken under considerably trying circumstances on the final day of a shoot when I knew I had only a few hours left in which to get the pictures I needed. The only thing that I had not tried, the one idea left untested, was to take a very long lens up to the top of a very tall building. I did not know what I would do once I got up there, but I felt confident that something interesting would turn up.

Once we had chosen the building that suited us, we managed to get permission to take photographs from the roof with comparatively little trouble, save for one niggling little detail. The management of the hotel we had chosen insisted that I sign an indemnity against the possibility of my falling off the top. Finding and signing the appropriate pieces of paper seemed to take forever, and by the time we had carried our equipment up in the service lift and out on to the roof the sun was beginning to set. The panorama of London landmarks laid out beneath me was breathtaking, but I could not begin to think of how to capture it on film. People in the street and details on the horizon looked interesting at first but seemed to pale

into insignificance beside the immensity of the view all around us. As the last rays of the setting sun caught a newly gilded statue in the distance I saw what I wanted (page 64). As the shutter clicked I saw something out of the corner of my eye and looked down at the street below where the red buses and telephone boxes were glowing out as the light faded (page 149). It took an assistant sitting on my legs to stop me going over the side but I got it.

Then, as the sun finally disappeared, I saw the last image I needed: the lights of the home-going cars weaving patterns in the dusk (above).

Although I had no way of knowing that the pictures would come out, although I still had to wait for them to be processed and printed, I felt an inward satisfaction. I knew somehow that all the effort had been worth-while. If I were forced to pick one incident that summarizes everything I know about my

Above Marble Arch at dusk: one of three pictures from an assignment I will never forget.

profession it would have to be that evening above London. For me the anticipation, the excitement, the satisfaction of actually creating images exceeds anything to do with mastering technique or possessing equipment. My job is to make pictures, and that, I think, is what photography is all about.

GLOSSARY

Aberration
A distortion created by uncorrected faults in lenses.

Additive colour process
A method of producing colour by adding one primary colour to another, characteristic of most early colour systems.

Aerial image
An image projected into space rather than on to a flat surface.

After-image
The image that remains on the retina for a short time after the original visual stimulus has been removed. This is particularly useful in cinematography, for producing an illusion of continual motion. The after-images of strongly coloured objects are always in a complementary colour.

Agitation
Intermittent or constant moving of solutions to ensure even contact between fluid and surface, especially important when developing films and prints.

Airbrush
A miniature paint-sprayer powered by compressed air that can produce very evenly graded layers of tone, used for modifying and retouching photographs.

Anamorphic lens
A lens design which can squeeze a panoramic view into a standard frame, producing a correct image when projected through another similar lens.

Anastigmat
A type of lens which corrects astigmatism.

Angström
A measure of the wavelength of light: $-\frac{1}{10,000,000}$th of a millimetre.

Aperture
The hole through which light passes to reach the film, usually of a variable diameter.

ASA
A standard of measurement (named after the American Standards Association which established the system) of the sensitivity of a film to light.

Astigmatism
A lens fault which causes vertical lines to be focused in a different plane to horizontal lines.

Autochrome
An early colour process that produced pictures made up of tiny coloured dots.

Autowinder
A motorized unit that automatically winds on film after exposure.

B
A setting on the shutter-speed control dial that keeps the shutter open as long as the shutter release button is depressed.

Backlighting
Any lighting situation which relies mainly on a light source placed directly behind the subject in relation to the camera.

Barndoors
Hinged adjustable flaps on the front of spotlights which allow the light to be more easily controlled.

Barrel distortion
A lens distortion that makes the sides of a rectangle appear to bulge outwards.

Base density
The density of the film base on its own, without the emulsion.

Bas-relief
A method of printing which combines a positive and negative transparency to produce an image which mimics the carved effects of low-relief statuary.

Bayonet mount
A means of attaching a lens to a camera body.

Bellows
A folding light-tight housing that can be introduced between lens and camera body to extend the effective focal length.

Bloomed (lens)
A lens that incorporates coatings.

Bracketing
Taking two or more identical shots of the same subject, allowing for different amounts of over or under exposure.

Burning in
Darkening the appearance of a selected part of an image by allowing more light to reach the photographic paper.

Cable release
A flexible cable that screws on to the shutter control button and enables it to be released from a distance. This is particularly useful when the camera has to be rock-steady during exposure.

Calotype
Also known as Talbotype, an early

photographic process and the first to be based on an intermediate negative stage.

Camera obscura
Literally a 'dark room' in which an image is thrown on to a flat surface by means of a lens. The principle involved was an important factor in the development of photography.

Cartridge
A container incorporating both film and take-up spool, used mainly in cheaper cameras.

Cast
Colour cast: a distinct tendency towards one or other of the primary colours.

Catadioptric
A lens design which utilizes both lenses and mirrors.

Catchlight
The reflection of a light source on the iris.

CDS
Cadmium sulphide, a high-sensitivity photo-conductor used in light-metering equipment.

Chiaroscuro
Form expressed in terms of light and shade rather than line. Derived from a technical term used by the Italian Renaissance painters.

Chromatic aberration
Uncorrected lens fault which produces coloured fringes at places where light and dark tones meet, caused by different wavelengths of light being focused in different planes.

Circle of confusion
Unfocused circular image produced by incorrect focusing.

Close-up lens
Supplementary lens which can be clipped or screwed on to a standard lens to allow for close focusing.

Collodion
Substance used as base for emulsion prior to introduction of gelatin.

Colour negative
A type of film which produces an intermediate negative image for colour reproduction.

Colour reversal
A type of film which produces a correctly coloured positive image directly from the original emulsion.

Colour temperature
Energy distribution over the spectral range, expressed in degrees Kelvin (K°).

Complementary
A complementary colour is the one primary colour which is not present in the original image. Blue and yellow = green, which is complementary to red; red and yellow = orange, which is complementary to blue, and so on.

Contacts
Contact prints: prints which are exposed directly through negatives laid on to photographic paper and producing images of the same (small) size.

Contre jour
A pretentious name for backlighting.

Converging lens
A lens which bends incoming rays of light together; another term for a concave lens.

Converging verticals
Distortion introduced by parallel lines photographed from any angle other than that which is parallel to the plane in which they lie, producing a false perspective.

Crop
To cut off parts of a photograph leaving only the important area of the main image.

Daguerreotypy
The earliest form of photographic process; it produced a thin positive image on a silver plate viewed by reflected light.

Dark slide
A holder for cut sheet film that protects it from the light.

Daylight film
Photographic film designed to give correctly balanced results when exposed to a light source of 5500 Kelvin.

Definition
Sharpness in a photographic image.

Depth of field
The extent of acceptably sharp definition in a view seen through a lens, extending further as the size of the aperture decreases.

Depth of focus
The distance through which film or a lens may be moved whilst still producing sharp images.

Diaphragm
A set of interwoven leaves (usually metal) which can be manipulated to produce apertures of continuously variable size.

Diffraction
Blurring of an image created by light grazing the sides of a hard edge, such as that of the diaphragm.

DIN
Deutsche Industrie Norm: a scale for measuring the comparative sensitivity of photographic emulsion to light.

Dodging
Lightening the appearance of a print by withholding light from part of it during printing.

Emulsion
A homogenous suspension of light-sensitive particles of silver halide within a neutral medium such as gelatin.

Extension tube
A light-tight tube placed between camera body and lens to obtain larger images of closer focus.

Fast
A fast film (400 ASA and upwards) is one which reacts to lower levels of light than a slow film.

Fill(-in)
A subsidiary light source used to illuminate shadow areas created by the main light source.

Filter factor
The amount by which exposure must be increased to compensate for the light held back by a filter.

Fisheye lens
A lens of very short focal length producing an angle of view approximating to 180°.

Fixing
Converting unused particles of silver halide into soluble salts that can then be removed from the emulsion by washing.

Flare
The reduction in contrast caused by light waves scattering as they bounce backwards and forwards within a lens.

Flood
A light source that produces a soft, even spread of light.

F stop
Aperture setting.

Focal length
The distance between the optical centre of a lens and its focal point.

Focal plane
The plane in which a lens brings images into sharp focus; more generally used to denote the area in the camera where film is held prior to, and during, exposure.

Focal plane shutter
A shutter which travels across the surface of the film.

Fresnel lens
A lens commonly used in camera viewfinders, consisting of a central plano-convex lens surrounded by a series of prismatic rings.

Grain
The noticeably rough-textured effect caused by individual particles of exposed silver halides grouping together as they are transformed into black metallic silver during the development process.

Guide number
A standardized scale which measures the output of flash guns.

Halides
A generic term for all light-sensitive salts of silver.

High key
The effect created from light-coloured tones with no shadows.

Hot shoe
A mount for a flash gun which contains the contacts for a synchronization circuit.

Infra-red
Wavelengths of light that lie beyond the visible red end of the spectrum but which can be recorded on infra-red-sensitive films.

Joule
A measure of electrical power, equal to one watt flowing for one second, most commonly used in connection with the output of larger flash units.

Kelvin
The temperature scale used to quantify colour temperature.

Latent image
A term describing the image stored, but not yet visible, in exposed emulsion.

Low key
Created from dark tones; shadowy.

Macrophotography
Any photographic process that produces an image on the emulsion which is larger than the original subject.

Microprisms
Small prisms, moulded on to glass, used to facilitate sharp focusing.

Motordrive
A faster and more robust version of the autowinder.

Nanometre
A measurement of the wavelength of light: $1/1,000,000,000$ metre.

Newton's rings
The rainbow effect produced when two transparent surfaces are almost but not quite touching, particularly noticeable in glass slide-mounts.

Optical glass
Glass manufactured to a predetermined index of refraction and used in lenses.

Panchromatic
A type of film which is expressly designed to reproduce all colours equally in black and white.

Panning
Moving the camera with a moving subject and exposing the film during the movement, thus reducing or eliminating blur caused by movement.

Parallax
The difference between two images produced by two lenses mounted parallel to each other but separated.

Pentaprism
A solid block of glass with five sides used to correct the view through the viewfinder in a single-lens reflex camera.

Plate camera
A camera designed to take large individual sheets of photographic emulsion rather than a series of frames.

Posterization
A printing and developing technique that results in several areas of sharply differentiated tone rather than a continuous gradation.

Push-processing
Extending the developing time of a film to compensate for its use at a speed-rating higher than intended by the manufacturer.

Reciprocity failure
The inability of some films to obey the usual law that dictates that it is possible to compensate for an increase in light levels by a reciprocal adjustment in exposure. It is most commonly noticed when long exposures produce colour casts in some films.

Reticulation
A crazed effect seen on prints which have been exposed to extreme changes of temperature during processing.

Shutter
The device in a camera which shuts out the light until it is released.

Slave
A subsidiary flash gun which is fired off when it detects light from another flash source.

SLR
Abbreviation for single-lens reflex camera, in which the view through the viewfinder corresponds exactly to the view through the lens.

Solarization
A process which can produce a partial reversal of normal tones by very brief fogging (exposure to light) during the development.

Spherical aberration
A lens aberration caused by different parts of the lens focusing light rays at different distances from the lens.

Spot meter
A light meter which measures the intensity of light at a given spot rather than over a wide field.

Standard lens
A lens whose focal length matches the diagonal of the film plane, approximately 50 mm for a 35mm camera, 80mm for a 2¼ square format.

Strobe
Very powerful, fast flash. In USA, a synonym for flash.

Subtractive colour process
Any colour process which produces results by filtering certain colours out of the colour pack rather than adding them.

Telephoto lens
Properly, any lens which folds up the light path within the lens to produce an optic which is shorter than its effective focal length; more commonly, any lens with a long focal length.

TTL
Abbreviation for Through The Lens, a system of light metering that measures the amount of light entering the lens of the camera.

Tungsten
The incandescent material used in most electric light bulbs; more commonly a generic term for any kind of medium-intensity artificial light.

Viewfinder
A lens which produces a view of the image seen by the camera either by bouncing light up from a mirror inside the camera body, or by placing a smaller equivalent lens in the front of the body.

Vignetting
The effect produced when the corners of a photographic image are cut off by the edge of a lens.

Zoom
A lens which offers a continuously variable focal length within certain constraints.

Acknowledgements

The author and publishers wish to thank the following for permission to reproduce photographs:

Bayerische Nationalmuseum, page 11; Eric Hosking, pages 184 and 185; Humanities Research Center, Austin, Texas, USA, page 10; Kodak Museum, pages 20–21; The Science Museum, London, page 13; Seaphotos, pages 182 and 183; Lord Shelbourne, pages 16–17; *The Sunday Times*, pages 178 and 179, photographs by Chris Smith; John Whyte, page 6.

All other photographs are by Patrick Lichfield, reproduced by kind permission of the following:
Allen, Brady and Marsh, page 92; Bayer pharmaceuticals, page 68 and 69; British Heart Foundation, pages 142–3, 144 and 176; Burberry, pages 124 and 125 (above); Camera Press, page 2; *Cosmopolitan*, pages 151 and 156; Dean's Blinds, page 116; *The National Enquirer*, pages 45–7, 63 and 72; Phonogram Records, page 134; Poulter Tenneson Co Ltd, page 167; *Radio Times*, page 157; Trafalgar Travel, page 56; *Vogue* pages 22, 26–7, 32 and 140; *Woman*, page 152.

We would also like to thank British American Tobacco, Singapore Airlines, Unipart, Garrat Balcombe, Action for the Crippled Child, Kodak Ltd and Peter Kain for permission to reproduce material.

The line illustrations are by Illustra Ltd, with the exception of the cut-away camera on page 23, which is reproduced by courtesy of Olympus Ltd.